The Women's History Guide
to Washington

Also by Jacci Duncan

*Washington for Women: A Guide to Working and Living
in the Washington Metropolitan Area*

Also published by Charles River Press

*I Have Arrived Before My Words:
Autobiographical Writings
of Homeless Women*
by Deborah Pugh and Jeanie Tietjen

*Until We Meet Again:
A True Story of
Love and Survival in the Holocaust*
by Michael Korenblit and Kathleen Janger

*Wave-Rings in the Water:
My Years with the Women of Postwar Japan*
by Carmen Johnson

The Women's History Guide to Washington

JACCI DUNCAN AND LYNN PAGE WHITTAKER

Charles River Press
Alexandria, Virginia
1998

Published by
Charles River Press
427 Old Town Court
Alexandria, VA 22314-3544

Cover design by Bonnie Campbell.
Cover photographs: the Star Spangled Banner and Mamie Eisenhower's red ball gown, both courtesy National Museum of American History, Smithsonian Institution; Mary McLeod Bethune in front of the U.S. Capitol, courtesy the Mary McLeod Bethune Council House, National Park Service; Elisabetta Sirani (1638-1665), *Melpomene, The Muse of Tragedy,* oil on canvas, 34 1/2 x 28 in., courtesy National Museum of Women in the Arts. Photograph of authors by Annie Scarborough. For other photo credits, see pp. 168-70.

This book is available at quantity discounts for special sales.
For information, call 703/519-9197.

Library of Congress Cataloging-in-Publication Data
Duncan, Jacci, 1964-
 The women's history guide to Washington / by Jacci Duncan and Lynn Page Whittaker.
 p. cm.
 Includes bibliographical references and index.
 ISBN 0-9647124-3-1 (pbk.)
 1. Washington (D.C.)—Guidebooks. 2. Historic sites—Washington (D.C.)—Guidebooks. 3. Women—Washington (D.C.)—Monuments—Guidebooks. 4. Women—United States—History.
 5. Women—Washington (D.C.)—History. I. Whittaker, Lynn Page.
 F192.3.D86 1998
 917.5304'41--dc21 97-49147
 CIP

Printed on recycled paper.
Manufactured in the United States of America

10 9 8 7 6 5 4 3 2 1

CONTENTS

INTRODUCTION

Did you notice the photograph of the Star Spangled Banner on the cover of this book? Did you also wonder what this revered historical object has to do with women's history? If so, you're not alone. In fact, when most people see this flag on display at the National Museum of American History, the person who comes to mind is inevitably Francis Scott Key, who saw it "still there" during a British bombardment of Baltimore and wrote the words that became the national anthem. But if it was Key who made the flag famous, it was Mary Pickersgill, a Baltimore seamstress, who actually made it. And not only is Pickersgill notable for creating those "broad stripes and bright stars," but she later founded one of the first social service programs for widowed or abandoned women, and not only did she feed and house them and their children, but she helped them develop skills to support themselves.

The story of Pickersgill and the flag has come to symbolize for us the heart of this book: Women's historical achievements are quite abundant in the Washington area, but you have to know where to find them. Stories can be found almost everywhere about women as notable artists, politicians, educators, reformers, advocates, journalists, physicians, nurses, aviators, scientists, and soldiers. *The Women's History Guide to Washington* will help readers come to know these women and the importance of their achievements alongside the more conventional history they learned in school, which emphasized the stories of men. And it will help both residents and tourists locate the sites and the specific items related to notable women. These include monuments, of course, but also objects these women owned, wore, used, and created, along with their portraits and archives including information on their and other women's lives.

In this book, the women are front and center: Martha Washington's name (not George's) appears in bold capital letters, and aspects of Mount Vernon important to her are emphasized; Susan B. Anthony, Alice Paul, Sojourner Truth, and other suffragists who earned women's right to vote are our subjects, rather than the Founding Fathers, who acquired voting rights for men; and Amelia Earhart, Jacqueline Cochran, and Sally Ride are the focus of the section on flight and space, as are women like Georgia O'Keeffe and Maya Lin in the arts and Shirley Chisholm and Frances Perkins in government. We highlight women as worthy of attention themselves, not merely as a sidebar to men's history. And these are just the stories we know about. Because many stories in women's history were never recorded or have been lost over time, we must celebrate what we do know about the pioneering women mentioned in these pages.

Writing this book has truly been an inspiration. After learning more about these great women, the struggles they endured to reach their goals, and their magnificent achievements, how could we not be inspired by them? Amelia Earhart sums it up best: "We must do the things we think we cannot." That's the thread that unites the women in this book.

We hope their stories will inspire you too so that you will want to learn more about these women and appreciate them as relevant to your own life. The next time to go to the ballot box, think of Alice Paul and others who endured the agony of force-feeding to gain the right for women to vote. The next time you admire the beautiful cherry blossoms along the Tidal Basin, remember that it was a group of determined women who put and kept them there. The next time you turn on your computer, keep in mind Grace Hopper, a young military woman who paved the way for the user-friendly operating system. And the next time you have the opportunity to learn a new craft or skill, think of Alma Thomas, who in her 60s began painting abstract art and became nationally acclaimed for her work. This is inspiration.

In fact, we discovered that many women in this book inspired each other. Nannie Helen Burroughs put a picture of Harriet Beecher Stowe on the wall of her school to inspire her students, while the courage of the young Joan of Arc in standing up for her beliefs inspired suffragists in both the United States and Europe. In many other instances, women helping each other brought about successes they could not have achieved alone. This also is inspiration.

The two of us are not historians; we are women's history buffs and enthusiastic tourists of our home community. Washington is a mecca for exploring women's history, whether for the first time or the hundredth, no matter what your age, your particular interest, or your previous level of knowledge. We hope this book will be a useful and enjoyable part of your journey.

. . . .

We want to call your attention to a couple of matters regarding your reading of this book. First, in each entry, we put the first reference to a woman in bold capital letters so they would be easier for readers to locate. Subsequent references within the entry are in regular type. Second, we included the dates for each woman only in the entry where the most information about her was provided. When a woman's name does not include her dates, check the cross-references at the end of each entry to find the one that includes that information. Finally, we are eager to hear your responses to this guide and your suggestions for women we should consider including in future editions. Please write to us at the address on the back of the book.

Many people helped with various aspects of creating this book. We first want to thank all those at the sites who gave so generously of their time, expertise, and advice: Joyce Bailey, Judy Bellafaire, Bill Birdseye, Liz Braden, Christine Brown, Stacy Coates, Dorothy Cochran, Holly Crider, Paula Felt, Steve Foreman, Sheridan Harvey, Courtney Holden, Portia James, Veronika Jenke, Kathleen Lynch, Kim Mayfield, Pam McConnell, Sally McDonough, Susan McElrath, Kate McFadden, Beth Miller, Johnna Miller, Betty Monkman,

Andrea Nichols, Fleur Pasour, Shana Penn, Leni Preston, Phyllis Rosenzweig, Susan Sinta, Auri Soltes, Steve Strauch, Maury Sullivan, Nancy Tuckhorn, Luann Colburn Vaky, General Wilma Vaught, Laurie Verge, Christopher With, Barbara Wolanin, Susan Wood, Jane Yarborough, and Nancy Yeide. Special recognition goes to Steve Hoglund and LaVerne Holmes who both provided research and fact-checking. Also, kudos to Annie Scarborough for capturing the moments.

In addition, we thank Donna Jonté and Eric Lindquist for reading the entire manuscript and offering many helpful suggestions, from the large to the small; we thank Eric also for important research help with the suggestions for further reading. We thank Elizabeth Hendrix for proofreading assistance and for fact-checking at the sites. Jacci especially thanks Carol Krause, who has continually provided expert advice on this book and everything else. Lynn also thanks her dogs, Kimi and Dusty, for their devoted companionship and for their superb service as vice presidents for security at Charles River Press.

Many friends and acquaintances—especially fellow members of the Women's National Book Association—have expressed support for this book. While we have occasionally wearied of having to tell them, "No, it's not out yet," we have never failed to appreciate their interest. An eager audience is surely the best motivator. Thank you all.

Finally, we could not have written this book without the women in our own personal histories. As the years and decades fly past, we more and more appreciate our mothers and their unflagging love and support and the stories of their lives. A tribute to notable women in history would not be complete without our expressing gratitude for all they have given us and taught us. Connie "Concetta" Duncan and Josephine Smith Page: you're great women in our book!

I. Capitol Hill

Here, in this grassy old cemetery overlooking the Anacostia River, rest the remains of three pioneering Washington women who spent their lives working for causes of importance to women and the country.

ANNE NEWPORT ROYALL (1769-1854), a trailblazing journalist, was recognized first for her spirited travel stories and later as a brash newspaper reporter and publisher. She founded the weekly newspaper *Paul Pry*, in which she challenged political figures and exposed wrongdoing. When that paper went bankrupt, she launched *The Huntress,* which she published until her death.

A popular story claimed Royall followed President John Quincy Adams on one of his regular swimming excursions to the Potomac River, then sat on his clothes on the bank until he gave her an interview. Although this tale is probably untrue, Royall was known for her fearless pursuit of stories and her refusal, as a publisher, to bend to pressure from those who objected to her editorial positions.

She was thus one of the earliest defenders of the First Amendment's freedom of the press.

In addition to exposing political corruption in her newpapers, Royall promoted such causes as ecology, municipal planning, and justice for American Indians. Her grave is in cemetery site 194, range 26.

CONGRESSIONAL CEMETERY

When **BELVA ANN LOCKWOOD** (1830-1917) moved to Washington in 1866, her part-time teaching job allowed her to pursue her interest in law and politics by observing debates in Congress and the Supreme Court. She next sought a position in the consulship at Ghent. She recalled the experience in 1888:

 Location:
1801 E St., SE
Metro: Potomac Ave. and Stadium Armory
Phone: 202/543-0539
Hours: daylight hours, daily
Amenities: brochures available at cemetery office for self-guided walking tour; guided tours on Saturdays at 11 am in the spring

"I fully believed that I was competent to perform the service required of a consular officer, never once stopping to consider whether the nation to which I should be accredited would receive a woman. To my disappointment and chagrin, no notice was ever taken of my application."

Lockwood was denied admission to the Columbia College (later George Washington University) law school, but was accepted into the new National University Law School, also in Washington. After graduation and admission to the bar, she ran a thriving legal practice in the basement of her home on F St., NW.

Among her legal accomplishments, Lockwood helped secure stronger property rights for married women and better pay for female federal workers. She was also the first woman allowed to argue cases before the U.S. Supreme Court. In 1884, Lockwood was the National Equal Rights Party's presidential candidate; this was 36 years before women had the right to vote.

Lockwood's grave shares a headstone with her daughter's family in cemetery site 296, range 78.

Artist **ADELAIDE JOHNSON** (1859-1955) was the official sculptor of the American women's suffrage movement. Johnson carved the enormous sculpture of Lucretia Mott, Elizabeth Cady Stanton, and Susan B. Anthony in the U.S. Capitol, as well as busts of suffrage leaders displayed in such places as the Sewall-Belmont House and the National Portrait Gallery.

At her wedding ceremony, performed by a woman minister, Johnson is said to have clothed the busts of Susan B. Anthony and Elizabeth Cady Stanton to serve as her bridesmaids. Her husband took her last name in marriage. Her grave is in cemetery site 152, range 61.

The cemetery also includes the mass grave of 21 women who were killed in an explosion at the Washington Arsenal in 1864. The 20-foot-tall Arsenal Monument is topped with a weeping woman, her head bowed.

The country's oldest national cemetery, Congressional Cemetery was established in 1807 as the burial site for members of Congress and other notable individuals. Also buried on the 32 acres are photographer Mathew Brady, long-time FBI Director J. Edgar Hoover, and more than 90 members of Congress.

See also: on Lockwood, pp. 31, 105; on Johnson, pp. 17, 21, 104.

The Folger Shakespeare Library contains the world's largest collection of Shakespeare's printed works and is renowned as a research institution on Shakespeare and the Elizabethan period. The library was founded by philanthropists and Shakespeare lovers Henry Clay Folger and his wife, with her husband to develop their collection of Shakespearean works. Over the years, she was responsible for many acquisitions, including rare musical instruments and several copies of the First Folio. The couple, who lived in New York state, traveled all over Europe to visit libraries, booksellers, and agents.

FOLGER SHAKESPEARE LIBRARY

EMILY JORDAN FOLGER (1858-1936). Henry began collecting works by Shakespeare after hearing a lecture by the aging Ralph Waldo Emerson at Amherst College, and Emily was a respected Shakespeare scholar.

In the 19th century, when few women attended college, Emily Jordan earned undergraduate and masters degrees in literature from Vassar College. She wrote her thesis on "the true text of Shakespeare," citing the 1623 First Folio as the "truest" text, but noting that even it was not perfectly accurate. Following college, she became an instructor in the Collegiate Department at the Nassau Institute in Brooklyn, New York.

After she married, the new Mrs. Folger began to work closely

Throughout their decades of collecting, the Folgers anticipated establishing a library to share their treasures with the American public. They chose Washington, D.C., partly

Location:
201 E. Capitol St., SE
Metro: Union Station or Capitol South
Phone: 202/544-4600; for group tours, call 202/675-0365
Hours: 10 am-4 pm, Mon.-Sat.
Amenities: gift shop, library, theater events, educational programs. Guided tours at 11 am, Mon.-Sat.; plus at 10 am, Tues., and 1 pm, Sat.

because it is the home of the federal government and partly because of Emily's affection for the city, beginning when her father was solicitor of the treasury under Presidents Lincoln and Andrew Johnson.

Unfortunately, Henry died two years before the library opened in 1932. However, Emily set up the research facility and oversaw the move of the collection from the storage warehouse to its new home. It took six months to transport and unpack the 75,000 books, prints and engravings, and manuscripts, as well as the 79 First Folios of Shakespeare's collected works, the largest collection of folios in the world.

Emily Folger continued to be active with the library until her death in 1936. Her ashes, along with her husband's, are interred there.

Women's Studies Materials

In addition to Shakespeare scholars, the library attracts researchers in women's history because the collection richly documents women's lives in early modern Europe. Highlights include:

• several documents signed by QUEEN ELIZABETH I and a 1579 portrait of her holding a sieve signifying her virginity. This is the earliest portrait of her with this symbol;

• a 1623 portrait of ELIZABETH, QUEEN OF BOHEMIA, daughter of James I;

• a book (c. 1533) inscribed by ANNE OF CLEVES to Henry VIII;

• the commonplace book of LADY ANNE SOUTHWELL (1588-1636), including her poems and a list of her possessions;

• approximately 100 letters to ELIZABETH, COUNTESS OF SHREWSBURY (1520-1608), also known as "Bess of Hardwick";

• books and other items owned by 16th- and 17th-century women on such topics as cooking, childbirth, and household furnishings; and

• hundreds of photographs and engravings of 19th-century English and American actresses.

The library has an active program of exhibitions drawn from its collections; these often relate to women in Elizabethan England. The building also houses a reproduction of an Elizabethan theater, where Shakespearean plays are performed and musical performances, lectures, and readings are given.

One of the most important repositories of national treasures in the world, the Library of Congress houses more than 28 million books and 101 million other items such as maps, manuscripts, photographs, and musical instruments. The first of its three buildings, the Jefferson Building

- a film of the famous 1913 women's suffrage parade along Pennsylvania Avenue;
- the papers of a number of notable women, including **MARY CHURCH TERRELL, NANNIE HELEN BURROUGHS, CLARA BARTON, HANNAH ARENDT, SANDRA DAY O'CONNOR,**

LIBRARY OF CONGRESS

(named for Thomas Jefferson, whose books formed the nucleus of the library), opened in 1897. It was built after the library outgrew its original location in the Capitol. The Adams Building was added in 1939; the Madison Building opened in 1980.

Manuscripts and Rare Books

The Manuscript and Rare Books divisions of the library contain a multitude of objects related to women's history. Items include:

- the papers of the National Woman's Party;
- suffragist **CARRIE CHAPMAN CATT**'s personal library;
- records of the National Association of Jewish Women;

Location: 1st St. & Indepen. Ave., SE
Metro: Capitol South or Union Station
Phone: 202/707-8000; TTY 202/707-9956. Group tours: 202/707-9779; general reference: 202/707-5522.
Hours: Main facilities open Tues., Fri., Sat., 8:30 am-5 pm; Mon., Wed., Thurs., 8:30 am-9:30 pm. Closed Dec. 25, Jan. 1, and every Sun. Great Hall open Mon.-Sat., 10 am-5:30 pm.
Web site: www.loc.gov
Amenities: cafeteria, gift shops. An orientation video runs continuously in the visitors center in the Jefferson Building. See p. 15 for tour information.

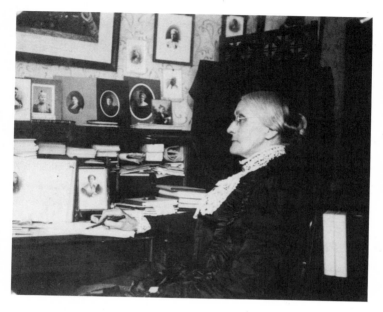

Susan B. Anthony at her desk

CLARE BOOTH LUCE, and **MARGARET SANGER;**

• **SUSAN B. ANTHONY'**s scrapbook and library, including her personal copy of Mary Wollstonecraft's *Vindication of the Rights of Woman* (1792);

• records of the Society of Woman Geographers, including membership files, newspaper clippings, and reports on members' research and travels, most notably some items owned by **AMELIA EARHART** and **MARGARET MEAD'**s field notes; and

• writings of Harlem Renaissance author **ZORA NEALE HURSTON,** including an unpublished short play discovered by a staff member in the manuscript division in April 1996.

The library also houses enormous microfilm collections, which include 19th-century women's books, pamphlets, and journals.

Unfortunately for the browser, the more rare materials are usually not on public display. Some, however, are available for research purposes and are shown as part of

special tours and exhibits. For information, call 202/707-6500.

Visual Representations

Another aspect of the library relevant to women's history is the decorative art of the Jefferson Building. Built in 1897 in the Italian Renaissance style, this edifice features numerous female figures as symbols.

The Great Hall, a 75-foot-high, two-level room lined with brightly colored marble, features images of women in murals, mosaics, and statues. Dr. Sheridan Harvey, women's studies specialist and reference librarian at the library, views these images as documents in women's history: "This use of the female form to personify disciplines, countries, virtues, seasons, senses, mythological tales, and symbolism reveals much about late Victorian ideas and attitudes about women and men. Perhaps," she suggests, "it is because women lacked power that their bodies can be used to represent abstractions."

Dr. Harvey also notes that, of the hundreds of real people named in the building, only one is a woman— SAPPHO, the ancient Greek poet.

The huge bronze doors at the building's main entrance are decorated with an image of MINERVA, Roman goddess of wisdom and war (also known as the Greek goddess Athena). Of the many Minerva images in the Great Hall, the most glorious is a 15-foot high mosaic of her holding a spear in one hand and unrolling a scroll of the departments of learning with the other. Her shield with the head of Medusa lies on the ground. An owl, symbolizing wisdom, is in the background, and a

IN THE WORDS OF Margaret Mead (1949)

"To the extent that either sex is disadvantaged, the whole culture is poorer, and the sex that, superficially, inherits the earth, inherits only a very partial legacy. The more whole the culture, the more whole each member, each man, each woman, each child will be."

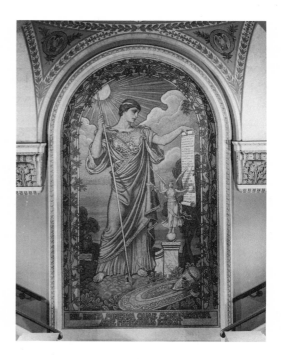

*Mosaic of Minerva
in the Great Hall*

statue of winged victory, Nike, is in the foreground.

Other images of women on the first floor include:

• Woman symbolizing *Good Government vs. Bad Government* (rear of the hall); and

• Woman representing *Lyric Poetry: Beauty, Passion, Pathos, Truth, and Devotion* (east corridor).

On the second floor are figures of women representing:

• *The Virtues:* Fortitude and Justice; Patriotism and Courage; Temperance and Prudence; Industry and Concord (two in each corner);

• *The Sciences:* Mathematics, Zoology, Physics, Geology, Archaeology, Botany, Astronomy, Chemistry (above the west corridor);

• *The five Senses* (ceiling, west corridor);

• *The four Seasons* (circular panels, south corridor);

• The *Arts or Graces* (ceiling, south corridor);

• *Literature* (ceiling, east corridor); and

• *Wisdom, Understanding, Knowledge, and Philosophy* (circular panels, north corridor).

Visitors taking the public tour will be led to a viewing area of the domed, circular Main Reading Room. Just above eye level are some of the ten-foot tall statues of women representing *the Disciplines:* Science, Law, Poetry, Philosophy, Art, History, Commerce, and Religion.

Materials for Research

The Library of Congress is the library of the American people, and most of its books, journals, and dissertations on all subjects, including women's history, are available to the public.

Current issues of periodicals are shelved for browsing in the Newspaper and Current Periodical Reading Room of the Madison Building.

Books and back issues of periodicals may be used in any of the several reading rooms by anyone with the required library identification card. A good place to start is with the reference librarian in the Main Reading Room on the first floor of the Jefferson Building. Visitors may obtain an identification card there,

along with a subject map for the library's three buildings. After the visitor acquires bibliographical information from the electronic card catalog and fills out and submits a call slip at the desk, library staff locate the requested material in the stacks and deliver it to you.

Although materials may only be used in the library, the collection is of critical value to researchers because it offers so much that is not available elsewhere.

For an overview of the entire library, guided tours begin in the Jefferson Building at 11:30 am and 1, 2:30, and 4 pm, Monday through Saturday. To join a tour, visitors should go to the information desk inside the 1st St. entrance.

See also: on Catt, p. 105; on Terrell, pp. 82-83, 84; on Burroughs, pp. 58-59; on Barton, pp. 19, 80-81, 129-31; on O'Connor, pp. 29, 30, 31; on Luce, p. 106; on Sanger, pp. 62, 106; on Anthony, pp. 8, 17, 19, 21, 59, 82, 104, 122; on Earhart, pp. 42-43, 106; on Sappho, p. 95, 126.

Entering this beautiful brick building instantly transports a visitor back into the early 1900s, when the women's suffrage movement gained momentum in Washington and across the country as dedicated activists convinced political leaders and others that women should have the right to vote.

her organization of the 1913 suffrage parade, one of the most significant in the United States. In this parade, thousands of women—many of them prominent—marched through the streets of the capital on the eve of Woodrow Wilson's presidential inauguration. As the women marched, the verbal and physical harrassment they

SEWALL-BELMONT HOUSE

ALICE PAUL (1885-1977), who founded the National Woman's Party, lived in this house from 1929 to 1972. Among her successes was

Location:
144 Constitution Ave., NE (next to the Hart Senate Office Bldg.)
Metro: Union Station or Capitol South
Phone: 202/546-3989
Hours: 10 am-3 pm, Tues.-Fri.; noon to 4 pm, Sat.
Amenities: gift shop; visitors must take docent-led tours, offered weekdays at 11 am, noon, and 1 pm, and on Saturday at noon and 1, 2, and 3 pm.

endured from onlookers generated sympathy for their cause.

The suffragists expanded their efforts in the following month to an aggressive lobbying effort. The turning point, however, came in 1917, when they began picketing the White House with banners emblazoned with political slogans. This was the first time any group in the United States used this now-popular tactic.

When some women, led by Alice Paul, were jailed and placed in solitary confinement as a result of these protests, they decided to go on a hunger strike to emphasize the political nature of their action. Jail officials, fearing repercussions if the women died, force-fed them—

sometimes three times a day. In this process, a tube was inserted into the woman's nose and down into her stomach. Force-feeding was not only painful and invasive, but it often resulted in stomach disorders and nasal damage.

ROSE WINSLOW, writing from the prison, described it this way: "Yesterday was a bad day for me in feeding. I was vomiting continually during the process. The tube has developed an irritation somewhere that is painful. . . . All the officers here know we are making this hunger strike that women fighting for liberty may be considered political prisoners; we have told them. God knows we don't want other women ever to have to do this over again."

The diligence and courage of these women finally paid off in 1920 with the passage of the 19th Amendment to the U.S. Constitution.

First Floor

As the long-time headquarters of the National Woman's Party, the house includes many objects from that organization's efforts. Displayed on the staircase wall is a faded purple and yellow banner that suffragists carried in a march on January 10,

Alice Paul

1917. This so-called Great Demand Banner reads: "We demand an amendment to the U.S. Constitution enfranchising women."

The house's entrance hallway is lined with sculptures and portraits of prominent suffragists, including busts of **SUSAN B. ANTHONY, ELIZABETH CADY STANTON,** and **LUCRETIA MOTT** sculpted by **ADELAIDE JOHNSON,** who also created the suffrage monument in the U.S. Capitol.

A sculpture of Alice Paul in this area reminds us that, after her suffrage work succeeded, she wrote the

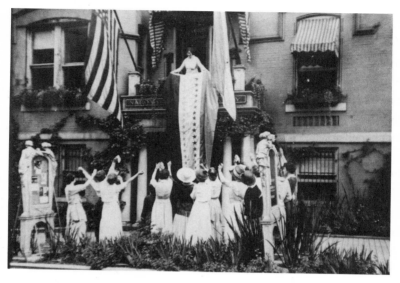

Alice Paul unfurls banner at the Sewall-Belmont House, 1920.

Equal Rights Amendment (ERA) in 1923 and worked for its passage. The wording is simple: "Men and women should have equal rights throughout the United States and in every place subject to its jurisdiction." Congress finally passed the ERA in 1972 and sent it to the states for ratification. Although the amendment passed in most states, it became a victim of anti-feminist backlash in the 1970s and failed to achieve ratification by the required 38 states within the constitutionally designated time.

Another tribute in the hallway is a jailhouse door pin. Alice Paul presented this image of a jail door chained with a heart-shaped lock to suffragists jailed with her in 1917. There are also statues of **JOAN OF ARC,** the patron saint of the British suffrage movement, and **JEANNETTE RANKIN,** the first woman elected to the U.S. Congress.

Prominent in this area is a large painting of **INEZ MILHOLLAND BOISSEVAIN** (1886-1916) on horseback with a banner decreeing "Forward Into Light." This beautiful young woman became a striking symbol of the suffrage movement.

Clad in a flowing white robe, Boissevain on her horse led many suffrage events, including the 1913

parade in Washington. She kept up a grueling pace, traveling throughout the United States speaking and leading marches. In 1916, after a march in Los Angeles, she collapsed and died soon after of exhaustion and pneumonia at the age of 31.

Also on the first floor is Alice Paul's office, furnished with the roll-top desk at which Susan B. Anthony worked on the 19th Amendment, and an early American spool chair used by Elizabeth Cady Stanton at the 1848 Seneca Falls Convention that launched the movement.

Other historical objects include the Equality Handkerchief, a man's handkerchief on which Susan B. Anthony sewed the letter "S" for suffrage; portraits and photographs of suffrage leaders; early drawings of the house; and a framed suffrage ribbon explaining the colors of the movement—purple for the glory of womanhood, gold for the royal crown of victory, and white for purity in home and politics.

Also in these rooms are a figurine of **SOJOURNER TRUTH,** former slave, abolitionist, and suffragist best known for imploring white suffragists to remember black women in the fight for equality, and a portrait of **ABIGAIL ADAMS,** wife of President John Adams, acclaimed for her plea to the founding fathers to "Remember the Ladies, and be more generous and favourable to them than your ancestors."

Portraits of founding members of the National Woman's Party, furniture and china used by **ALVA BELMONT** (1853-1933), the organization's most generous benefactor, and a silver service set used by **CLARA BARTON,** founder of the American Red Cross, are also found in this area.

IN THE WORDS OF Sojourner Truth

"If the first woman God ever made was strong enough to turn the world upside down all alone, these women together ought to be able to turn it back, and get it right side up again!"

Second Floor

Upstairs, the hallway is lined with political cartoons from the suffrage movement and stirring photographs of the early ERA campaign and of the World Woman's Party which Alice Paul established in 1938 in Geneva to seek equal rights for women around the world. Also on this floor is Alice Paul's simply furnished bedroom, with her mahogany four-poster bed, a revolving bookcase, and the drop-leaf desk where she did much of her work.

The rest of the house is decorated with period furniture from various sources, including an elegant parlor set on the first floor donated by William Randolph Hearst in honor of his mother, who was a suffragist. The house gets its name from longtime owner Robert Sewall and from supporter Alva Belmont.

See also: on Paul, p. 59; on Anthony, pp. 8, 12, 21, 59, 82, 104, 122; on Stanton, pp. 8, 21, 59, 104-5, 122; on Mott, pp. 8, 21, 104; on Johnson, pp. 8, 21, 104; on Joan of Arc, pp. 119-20, 122; on Rankin, pp. 24, 27; on Truth, pp. 107, 122; on Adams, pp. 54, 112, 113; on Barton, pp. 11, 80-81, 129-31.

V isitors to the Capitol who ask whose statue is on top of the dome are often surprised to learn that it is not a real woman at all, but a female figure known as Freedom. The 15,000-pound, 19 1/2-foot tall bronze is of a cloaked woman wearing a helmet with an eagle head. One of her hands suffrage movement. Titled "Portrait Monument to Lucretia Mott, Elizabeth Cady Stanton, and Susan B. Anthony," the piece consists of busts of these women carved into an eight-ton block of marble. The sculpture by **ADELAIDE JOHNSON** was a gift from the National Woman's Party in 1921, one year after women

U.S. CAPITOL

holds a laurel wreath of victory and the United States shield with 13 stripes; in the other hand is a sheathed sword. At the statue's base are the words "E Pluribus Unum" ("Out of Many, One"), a phrase of particular importance during the Civil War, when the statue was placed on the dome as a symbol of democracy.

Inside the Capitol, among the multitude of items reflecting American history, the number honoring women is relatively small. Visitors who know where to look, however, will find notable women from many fields of endeavor.

The Capitol Rotunda

Perhaps the most recognizable image of women inside the Capitol is a tribute to three of the leaders of the

earned the right to vote with the 19th Amendment to the Constitution.

This sculpture generated much debate in Washington in the 1990s.

Location:
1st St. between Independence and Constitution Aves.
Metro: Capitol South or Union Station
Phone: 202/224-3121
Hours: Rotunda and Statuary Hall: 9 am-8 pm, daily. Other areas: 9 am-4:30 pm, daily.
Amenities: gift shop, cafeteria, guided tours Mon.-Sat. that originate in the Rotunda. Senate and House galleries open to the public when in session; tickets may be obtained from your member of Congress.

For more than seven decades, it was displayed in the ground-floor crypt, a relatively remote area. But supporters complained that, as a tribute to those who gained the vote for over 50 percent of the American people, it deserved more prominence, and they lobbied Congress to have it moved upstairs to the Rotunda. After lengthy debate, Congress finally approved the move, and private funds were raised to pay for the transfer. In June 1997 the statue was rededicated in the Rotunda.

Behind another statue in the Rotunda lies an amazing story in women's history. In the 1860s, **VINNIE REAM** (1847-1914) was a largely self-taught sculptor from Wisconsin who worked at the U.S. Post Office. Although only 17 years old, her ambition was to sculpt President Abraham Lincoln. Upon hearing that Ream was poor and in need, the president agreed to let her sketch him at the White House.

The young sculptor grew fond of Lincoln during the nearly daily half-hour sittings over the course of several months and even saw him the day he was assassinated in 1865. After completing the bust, she was commissioned by the federal government to create a full-size statue—the first time a woman received a federal art commission.

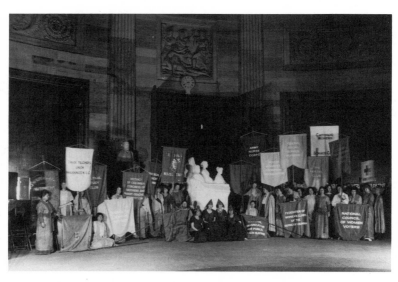

Dedication of the suffrage monument in 1921

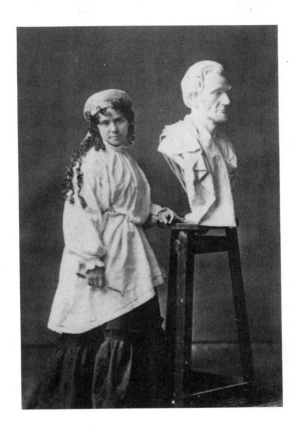

Vinnie Ream with her bust of Lincoln

In 1870, when the statue was unveiled, Ream received high praise for effectively capturing Lincoln's personality in the marble.

Ream later married, becoming Vinnie Ream Hoxie, and was acclaimed as a successful artist. Among her other works are statues of Samuel Kirkwood and Sequoya in the Capitol's National Statuary Hall and of Admiral Farragut in Farragut Square. Her successes helped open the door for other women artists of the 19th century.

Also located in the Rotunda are three depictions of **POCA-HONTAS,** the daughter of a Powhatan chief, who is credited with helping build friendship between the Indians and the colonial settlers. "The Baptism of Pocahontas" is one of eight huge paintings depicting important events in early America. The famous story of Pocahontas saving

settler John Smith from being killed by Indians is depicted in a stone relief over the west door and a fresco at the base of the dome.

Another of the Rotunda paintings, "Embarkation of the Pilgrims," shows pilgrim wives—Mrs. Brewster, Mrs. White, Mrs. Winslow, Mrs. Fuller, Mrs. Rose Standish, Mrs. Bradford, and Mrs. Carver—arriving at Plymouth Rock in Massachusetts.

National Statuary Hall

American women of achievement are honored in six statues in the National Statuary Hall collection, where each state has been allowed to place statues of two individuals of their choice.

The most famous woman represented there may be **JEANNETTE RANKIN** (1880-1973), the first woman to serve in the U.S. Congress. She was elected by Montana voters in 1916, four years before American women had the right to vote. Montana, however, had already passed a suffrage amendment.

Rankin did not win reelection until 1940. In both her first term (at the start of World War I) and in 1941 (at the U.S. entry into World War II), she voted against entering the war. She was the only member to do so for both wars, the second time as the lone dissenter. When not in public service, Rankin lobbied for peace and consumer causes and was an ardent protester against the Vietnam War.

Statues of five other women appear in Statuary Hall, the Senate connecting corridor, and the Hall of Columns. They are:

• **ESTHER HOBART MORRIS** (1814-1902) of Wyoming was the nation's first woman justice of the peace and a leader in getting Wyoming to be the first state to approve a suffrage amendment.

• **MOTHER JOSEPH** (1823-1902), a nun and architect, led a group of missionaries to the Pacific Northwest Territories in 1856. There, she was in charge of raising money for and overseeing the construction

IN THE WORDS OF Frances Willard (1905)

"Sow an act and you reap a habit; sow a habit and you reap a character; sow a character and you reap a destiny."

of eleven hospitals, seven schools, five Indian schools, and two orphanages. Honored for her service by the state of Washington, she is often called"the first architect of the Pacific Northwest."

- Dr. **FLORENCE RENA SABIN** (1871-1953) of Colorado is honored for her work as an educator and for modernizing the state's public health system. In 1900, she became the first woman to graduate from Johns Hopkins Medical School and the first woman to become a full professor there. In 1944, she gave up retirement to chair a Colorado subcommittee on health. Her improvements to the state's health care system became known as the "Sabin Health Laws."

- **FRANCIS WILLARD** (1839-98) of Illinois was, in 1905, the first woman memorialized with a statue in the Capitol and remained the only one for five decades. Willard, a suffragist, was president of the Evanston College for Ladies and became dean of women when it merged with Northwestern University. She is best known for her vigorous leadership of the temperance movement as president of the Woman's Christian Temperance Union (WCTU).

- **MARIA SANFORD** (1836-1920) of Minnesota was an educator, civic leader, and champion of women's rights. After using her dowry to attend college, she became a school principal and superintendent. A founder of parent-teacher organizations, she was also one of the first women to be named a college professor. Sanford was often referred to as "the best-known and best-loved woman in Minnesota."

While in Statuary Hall, visitors should notice the white double doors on the east side. Although not open to the public, the doors form the entrance to a suite that serves as a meeting area exclusively for women members of Congress.

When women were first elected, there were no restrooms for them close to the House floor, so those in this suite became the designated "women's room." The suite, now known as the Congressional Women's Reading Room, is dedicated to **LINDY CLAIBORNE BOGGS** (1916-), who represented Louisiana for two decades until her retirement in 1991. Boggs, who is the mother of journalist **COKIE ROBERTS,** is currently U.S. Ambassador to the Vatican.

● *on this spot:* U.S. CAPITOL ●

Women have often brought national attention to critical issues at the Capitol. The 1990s saw First Lady **HILLARY RODHAM CLINTON** testify for health care reform, National Endowment for the Arts Chairman **JANE ALEXANDER** advocate support for artists, and attorney **ANITA HILL** awaken the country about sexual harassment.

In 1965, the Capitol was the spot for a remarkable protest led by three black women from Mississippi. Legendary activist **FANNIE LOU HAMER** (1917-77), along with **ANNIE DEVINE** and **VICTORIA GRAY,** challenged the seating of five white men from Mississippi in the House of Representatives, arguing that black Mississippians were effectively denied the vote in the 1964 election. Local officials had used intimidation, threats, and even violence to prevent African-Americans from exercising their legal right to vote. They had also refused to place the three women's names on the ballot.

On January 4, the first day of the new session of Congress, black working people from Mississippi who'd come to support the challenge stood silently, ten yards apart, in the tunnel leading to the Capitol as the Congressmen walked past. The moral force of their presence had a powerful effect, changing the minds of many on the spot. When the House proceedings began and Rep. William Ryan (D-NY) rose to make the challenge on behalf of the women, 70 Representatives stood with him in symbolic agreement. Hamer and her group were thrilled; they had hoped for about 15.

Eight months later, the House finally voted down the challenge. But that was after the challengers' attorneys had used it to collect information on voting irregularities across Mississippi and after the passage of the 1965 Voting Rights Act. On the day after the vote, Hamer stood on the Capitol steps and vowed to "come back year after year until we are allowed our rights as citizens." She did.

Women in Congress

Unfortunately, the small number of women honored in the Capitol is matched by small numbers in the Congress. In the 105th Congress (1996-98), women comprise only 9 percent of the Senate and 12 percent of the House of Representatives.

Because of this minimal representation, it is said that every woman elected to Congress has the potential to make history. Here are some who already have:

• **JEANNETTE RANKIN** (R-Montana) was the first woman elected to the House of Representatives; she was elected in 1916.

• **SHIRLEY CHISHOLM** (D-NY) was the first African-American woman in the House of Representatives; she was elected in 1968.

• **HATTIE CARAWAY** (D-AK) was the first woman elected to the Senate. She had been appointed to fill her late husband's term, but successfully won reelection in 1932.

• **NANCY KASSEBAUM** (R-KA) was the first woman to chair a major committee (the Senate Foreign Relations Committee).

• In 1992, **CAROL MOSELEY BRAUN** (D-IL) became the first African-American woman to be elected a U.S. senator.

• **MARGARET CHASE SMITH** (R-ME) was the first woman to serve in both the House and the Senate; she was elected to the House in 1940 and the Senate in 1948.

• **DIANNE FEINSTEIN** (D-CA) and **BARBARA BOXER** (D-CA) became, in 1992, the first women to occupy both Senate seats from a state.

• **PATRICIA SCHROEDER** (D-CO) holds the women's record for years of service in the House of Representatives—from 1972 until she retired in 1996. In her role as the senior woman in Congress, Schroeder instigated the designation of the Congressional Women's Reading Room.

• **GERALDINE FERRARO** (D-NY) was the first and still-only woman to run as the vice-presidential candidate of a major party. When Democratic presidential nominee Walter Mondale selected Ferraro as his running mate in 1984, she had been a representative for three years.

IN THE WORDS OF Shirley Chisholm (1970)

"Tremendous amounts of talent are being lost to our society just because that talent wears a skirt."

To keep women's issues on the agenda and to make women citizens' voices a part of national debates, it is important for women to make their opinions known to their members of Congress. To find out how to contact your representatives, call the congressional switchboard at 202/224-3121. You can also visit the House's Web site at www.house.gov or the Senate's at www.senate.gov.

To obtain tickets to view a floor session in the House or Senate, contact your member of Congress. Although seating is limited, committee hearings are open to the public. Their schedules appear daily in the *Washington Post*.

Women with an interest in running for Congress will find a number of organizations that offer advice and fundraising assistance. Good places to start are the National Women's Political Caucus (which is bipartisan), EMILY's List (for Democratic women), and the WISH List (for Republican women).

See also: on Mott, pp. 8, 17, 104; on Stanton, pp. 8, 17, 19, 59, 104-5, 122; on Anthony, pp. 8, 12, 17, 19, 59, 82, 104, 122; on Johnson, pp. 8, 17, 104; on Ream, pp. 95, 126; on Pocahontas, p. 103; on Rankin, p. 18.

Oyez! Oyez! Oyez! History was made on September 26, 1981, when Justice **SANDRA DAY O'CONNOR** became the first woman to sit on the Supreme Court in nearly 200 years.

Twelve years later, on August 10, 1993, Justice **RUTH BADER GINSBURG** too made history as the different directions until they both became Supreme Court justices.

Prior to her appointment to the court, O'Connor had dedicated her career to public service. After graduating from Stanford law school and discovering the law firm to which she applied would only hire her as a secretary, she took a position as a deputy

U.S. SUPREME COURT

second woman to be sworn in to the highest court of the land. Together, their presence changes the way Americans view the court and the way the court views America.

Both O'Connor and Ginsburg were early achievers encouraged by their mothers. O'Connor's spent hours reading to her from newspapers and magazines. Ginsburg's mother took her on frequent trips to the library and saved her pin money for her daughter's college education. Both women excelled in law school, rising to the top of their classes and making law review. After graduation, both women faced gender discrimination when they sought professional-level positions with law firms. After that, their careers went in

county attorney in San Mateo, California. Later, when she accompanied her military husband overseas, she worked as a civilian attorney. After returning to her home state of Arizona and giving birth to her first child, she opened her own practice and began serving on local boards and commissions. She excelled in public service and, in 1965, became assistant state attorney general.

Location: 1st and East Capitol Sts., NE
Metro: Capitol South
Phone: 202/479-3000
Hours: 9 am-4:30 pm, Mon.-Fri.
Amenities: cafeteria, snack bar, gift shop, exhibits, educational programs

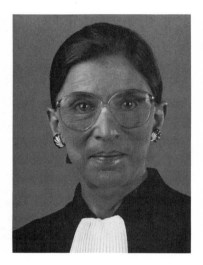

Justice Sandra Day O'Connor *Justice Ruth Bader Ginsburg*

Four years later, O'Connor was appointed to fill a vacancy in the state senate. She was reelected to that seat, as a Republican, for two more terms. In 1972 she was elected state senate majority leader—the first woman in the country to hold such a position.

From there, O'Connor became a judge on the Maricopa County Superior Court and was encouraged by Republicans to run for governor. She declined. After the election, however, the new governor appointed her to the Arizona Court of Appeals. After only 21 months, President Ronald Reagan nominated her to the U.S. Supreme Court. She is the only sitting justice to have served in all three branches of government.

Justice O'Connor was appointed to the Supreme Court one decade after women were first given legal protection from gender discrimination in the case of *Reed v. Reed* in 1971. This first major decision against gender discrimination laid the groundwork for additional rulings on equity issues and led to better representation of women in the legal profession, including lawyers and judges.

The second woman on the Supreme Court played a key role in this legal process and worked on the case of *Reed v. Reed*. Before joining the court, Ruth Bader Ginsburg gained national recognition for her work on gender equity within the law, which

paved the way for professional and personal opportunities for women.

After graduating from Columbia Law School in New York, Ginsburg became the second woman to join the law faculty of Rutgers University. When she was asked to teach a course on sex-based discrimination, she soon realized how little had been done on the subject and began her quest to redress gender inequities.

Her argument was that women received inferior treatment as a result of social conditioning and that such unfair treatment harmed not only women, but the family too and therefore all of society.

As leader of the Women's Rights Project of the American Civil Liberties Union (ACLU), Ginsburg spent nearly a decade trying to persuade the court on which she now sits to review gender-based discrimination cases with heightened scrutiny. Her argument led to many victories in court, and today, legal prohibition of gender discrimination is well estab-lished. President Clinton appointed her to the Supreme Court in 1993.

Appearing Before the Court

Perhaps not surprisingly, women gained the right to argue before the Supreme Court long before any appeared on the bench—although even that did not come easily.

BELVA LOCKWOOD earned her law degree, was admitted to the District of Columbia bar, and practiced law for a number of years—all accomplishments achieved against great resistance. Finally, after a five-year struggle, including lobbying for passage of special legislation in both the House of Representatives and the Senate, Lockwood became in 1879 the first woman allowed to argue before the Supreme Court.

Even now, the number of women who appear before the court is small. The May 27, 1997, *Washington Post* reported that only 14 percent of the 203 lawyers who appeared in the 1996-97 term were female.

IN THE WORDS OF Justice Sandra Day O'Connor (1989)

"Despite the encouraging and wonderful gains . . . for women which have occurred in my lifetime, there is still room to advance and to promote correction of the remaining deficiencies and imbalances."

This low percentage is attributed to the years of legal experience usually required before attorneys reach that stage in their careers. With women now half of all current law students, that inequity should change over time.

Women in Stone

As with the architecture of other government structures in Washington, female figures are used on and in the Supreme Court building to symbolize justice and liberty.

At the entrance is "The Contemplation of Justice," a large marble statue of a seated woman, holding Themis, a symbol of justice, in her right hand. In another representation above the building's doorway, the figure of a seated woman flanked by male protectors appears above the words "Equal Justice Under Law." She personifies liberty and justice.

Inside the court chamber, on the frieze encircling the walls above the pillars, a female figure in the section directly across from the justices' bench represents Justice, Divine Inspiration, Truth, and Wisdom.

Visiting the Court

Visitors can attend proceedings when the court is in session from October to April, except for federal holidays. The sessions—on Mondays, Tuesdays, and Wednesdays—start at 10 am, but because seating is limited, visitors line up early. In May and June, the court releases opinions to the public each Monday starting at 10 am. When the court is not in session, visitors can peer inside at the chamber.

See also: on O'Connor, p. 11; on Lockwood, pp. 7-8, 105.

II. The Mall

The bronze statue of **ELEANOR ROOSE-VELT** (1884-1962) near the Tidal Basin is a little larger than life, yet welcoming and approachable. An observer standing nearby will see a steady stream of tourists step up onto the statue's base, lean comfortably against her big arms, United States and around the world until her death in 1962. Without doubt, she is one of the most significant women in American history.

As first lady for 12 years, Roosevelt transformed the largely ceremonial role into one of substance and influence. Although some criticized her activism, her clear vision

ELEANOR ROOSEVELT STATUE

and smile into their companions' cameras. Person by person, cluster by cluster, visitors of all ages, races, and nationalities—each has a turn.

It's a fitting tableau for a woman whose compassion and courage have inspired generations. A life-long humanitarian and tireless advocate for women, minorities, and the poor, Roosevelt was America's first delegate to the United Nations, chair of the United Nations Commission on Human Rights, a prolific author, and mother of six.

As wife of President Franklin Roosevelt, she helped the country through the Great Depression and World War II. After his death in 1945, she continued to play a major role in political and social issues both in the

of a more equal world never wavered, and she pushed her agenda publicly and privately with great success.

With her radio show and newspaper columns ("My Day" and "If You Ask Me"), she proved herself an

 Location: within the FDR Memorial, along the Tidal Basin in West Potomac Park, West Basin and Ohio Dr. (near the Jefferson Memorial)
Metro: Foggy Bottom, then walk southeast about a mile
Phone: 202/426-6841
Hours: 8 am-midnight, daily
Amenities: book shop (8 am-10:30 pm daily)
Web site: www.nps.gov/pha

effective user of the media to communicate her messages. She was the first of the first ladies to hold press conferences—some solely for female journalists. Among the many ways she used her role to help women, she hosted meetings with working women at the White House to hear their needs and concerns, and she held them on the weekend to fit with the women's schedules.

She also worked for equal rights for African-Americans, from planning political strategy with her friend **MARY MCLEOD BETHUNE** to attending civil rights meetings in the South despite threats on her life. And not only did she arrange for **MARIAN ANDERSON** to sing at the Lincoln Memorial, but she resigned publicly from the DAR to protest its exclusion of Anderson because of her race.

The statue of Roosevelt is part of the sprawling, open-air memorial to President Franklin Roosevelt and his administration that opened in 1997. Her statue, in an alcove near the end of the exhibit, depicts an aging Eleanor in a plain suit, her hands clasped before her, gazing resolutely ahead. On the wall behind her are carved some of her husband's words on peace.

Some of Eleanor's own inspiring maxims include: "Justice cannot be for one side alone, but must be for both"; "We cannot exist as a little island of well-being in a world where two-thirds of the people go to bed hungry every night"; "You gain strength, courage, and confidence by every experience in which you really stop to look fear in the face"; and "The future belongs to those who believe in the beauty of their dreams."

See also: on Roosevelt, pp. 54, 56, 85-86, 106, 112, 115, 138; on Bethune, pp. 85-87; on Anderson, pp. 84, 107.

● *on this spot:* LINCOLN MEMORIAL ●

On the steps of the Lincoln Memorial, with the great president's statue looking on, one can still hear the voice of Dr. Martin Luther King, Jr., proclaiming his dream for freedom.

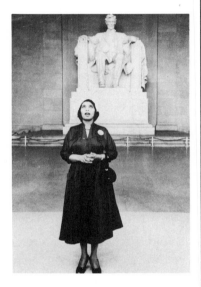

Marian Anderson at the Lincoln Memorial one year after the famous concert.

But also in the air are the pure contralto tones of **MARIAN ANDERSON** (1897-1993), an internationally acclaimed opera singer whose 1939 concert at the DAR's Constitution Hall was cancelled because she was black. Under the urging of First Lady Eleanor Roosevelt, Secretary of the Interior Harold Ickes arranged to hold the concert at the Lincoln Memorial, and Anderson sang before a crowd of 75,000 on Easter Sunday. In her autobiography, Anderson recalls: "The crowd stretched in a great semicircle from the Lincoln Memorial around the reflecting pool on to . . . the Washington Monument. I had a feeling that a great wave of good will poured out from these people, almost engulfing me. And when I stood up to sing our National Anthem I felt for a moment as though I were choking. . . . I sang, I don't know how."

In time, the DAR changed its policy, and Anderson performed at Constitution Hall on two occasions. She became the first African-American woman to perform in New York's Metropolitan Opera and a recipient of the Presidential Medal of Freedom.

A mural in the Interior Department building (C St. between 18th and 19th Sts., NW) commemorates the Lincoln Memorial concert.

Because art often reflects life experiences of the artist, it's not surprising that gender frequently plays a significant role in works by women artists. Many such works can be viewed at the Hirshhorn Museum and Sculpture Garden, which offers a comprehensive collection of modern and contemporary art housed in a drum-shaped building, along with more than 2 1/2 acres of outdoor sculpture.

Curator Phyllis Rosenzweig says works by women in the collection, although few in number, are representative of the experiences of women over the last 200 years. "These numerically skewed proportions represent the larger historical and social biases and lack of opportunities for women in Europe and the United States for most of the 19th and 20th centuries," she says. "However,

HIRSHHORN MUSEUM AND SCULPTURE GARDEN

despite their small numbers, women are represented in the Hirshhorn by bold and important works from virtually every period covered by the collection. The representation of women increases as we approach the present time, as women have achieved equal status and become innovators and commentators on contemporary society."

The collection includes compelling works by more than 100 female artists, including the following:

• Impressionist artist **MARY CASSATT** (1844-1926) painted mostly women and children in domestic settings. Her pastel drawing *Young Girl Reading* (1894) shows a girl deep in concentration.

Location:
Independence Ave. and 7th St., SW
Phone: 202/357-2700;
TTY: 202/357-3235
Hours: 10 am-5:30 pm, daily
Amenities: video introduction in the Orientation Theater, guided tours, gift shop, special exhibitions, outdoor cafe (summer only)
Web site: www.si.edu/organiza/ museums/hirsh/homepage/ start.htm

• **GEORGIA O'KEEFFE** (1887-1986), one of the most popular American artists, took inspiration from nature and her life in the Southwest to create her dramatic paintings. The collection includes her *Goat's Horn with Red* (1945), a pastel in which a goat's horn is used as a frame for the blue sky beyond. This painting is typical of O'Keeffe's later work based on animal fragments she collected from her New Mexico landscape. The collection also includes her *Black Hills With Cedar.*

• **LOUISE NEVELSON** (1900-88) is best known for her huge wood sculptures of found objects painted in a uniform color. The doors of *Dream House XXXII* (1972) open to reveal mysterious spaces.

• **BARBARA HEPWORTH** (1903-75) is known for her smoothly polished, abstract carvings. *Reclining Figure* (1933), made of alabaster, is in a style she developed from Surrealist biomorphic forms, and *Pendour* (1947-48) is a horizontal, complexly curved work. The artist used her love for nature and natural forms to convey the flow and serenity of the natural world. Hepworth also made stringed compositions such as her *Head* (1952).

• One of the most popular pieces in the museum is *The Blind Leading the Blind* (1947-49), a multi-level wood sculpture by **LOUISE BOURGEOIS** (1911-). The painted pink work's two rows of wooden posts held together by a horizontal post are said to symbolize anonymous, unindividualized persons. Bourgeois created it in the late 1940s when artists were being investigated by the House Un-American Activities Committee for alleged Communist ties.

• Art by **ELIZABETH MURRAY** (1940-) is always an excursion into the female psyche. *In the Dark* (1987), a three-dimentional work on a ragged-edge canvas, features a human form suspended with arms and legs flailing and a hole in the torso.

IN THE WORDS OF Louise Nevelson

"I still want to do my work, I still want to do my livingness. And I have lived. I have been fulfilled. I recognized what I had, and I never sold it short. And I ain't through yet!"

• **SUSAN ROTHENBERG** (1945-), whose work reintroduced imagery in a period of art history dominated by abstraction, painted *IXI* (1976-77) and several others in the series based on the silhouette of a horse. The title of the large red and maroon painting represents the horse's awkward form, enclosed by vertical and crossing lines.

• **JUDITH SHEA** (1948-) has made her mark on the art world by using stiffened clothing to create bronze and cast stone sculptures. Influenced by her earlier career as a clothing designer and by viewing ancient sculptures that survived in fragments, Shea casts clothing— minus body attributes—as an expression of persona. Her lifesize bronze *Post-Balzac* (1991) is on view in the sculpture garden.

Because the Hirshhorn, like most museums, owns more works than it can exhibit at once, pieces are rotated between display space and storage. Consequently, artists and their works mentioned here may not be available for viewing at the time of your visit. Check at the information desk for their display status.

See also: on Cassatt, pp. 47, 98, 105; on O'Keeffe, pp. 47, 48; on Nevelson, pp. 49, 94-95, 101; on Bourgeois, pp. 48, 95; on Rothenberg, p. 49.

● *on this spot:* U.S. CABINET DEPARTMENTS ●

A s headquarters of the federal government, Washington is the location of achievements by women at all levels of government service. Those who have headed cabinet departments play an especially key role in the making and implementation of public policy.

This honor roll is led by **FRANCES PERKINS** (1882-1965), who was the first woman named to a presidential cabinet. A life-long advocate of workplace reform, Perkins helped convince the state of New York to improve sweatshop conditions. As the first woman New York State Industrial Commissioner, she became a close advisor to then-Governor Franklin Roosevelt, who named her secretary of labor when he was elected president—a position she held for 12 years.

(cont. on next page)

on this spot (cont.)

Perkins, who went to court to keep her birth name when she married, may be best remembered for her strong advocacy of a minimum wage. Her biggest accomplishment, however, was shepherding into law a batch of labor reform legislation that included the Social Security Act, child labor laws, and federal aid to states for unemployment. The U.S. Labor Department headquarters at 200 Constitution Ave., NW, is named the Frances Perkins Building and has a small exhibit on her life.

Other notable women in presidential cabinets include:

Daughter of a dining-car porter, **PATRICIA ROBERTS HARRIS** (1924-85) first promoted change as a student by joining a sit-in to desegregate an all-white cafeteria in the District. After graduation from Howard University Law School, Harris worked for the YWCA and the Department of Justice. In 1965, President Lyndon Johnson appointed her ambassador to Luxembourg, the first black woman to hold an ambassadorial post. In 1976, Harris became the first black woman cabinet secretary as President Carter's choice for secretary of housing and urban development. In 1979, she was named secretary of health, education, and welfare and later served as the first black American delegate to the United Nations. Harris is buried in Rock Creek Cemetery; her portrait is in the National Portrait Gallery.

When President Clinton named **JANET RENO** (1938-) U.S. attorney general and **MADELEINE ALBRIGHT** (1937-) secretary of state, they became the first women to hold those key cabinet posts. Reno, a Florida prosecutor, became U.S. attorney general in 1993. Albright, a Georgetown University professor, was U.S. ambassador to the United Nations during Clinton's first term; she became secretary of state in 1997. Because the secretaries of the Justice and State departments are in the direct line of presidential succession and their responsibilities are for constitutionally designated areas, they are considered the two most powerful cabinet positions.

Each year, more than eight million visitors—the most of any museum in Washington—come to the Air and Space Museum to view its exhibits ranging from the first attempts to fly all the way through space exploration. Since the early days of wood and fabric airplanes, flight has been a field dominated by men, yet notable accomplishments by women have found a place in the museum as well.

AMELIA EARHART (1898-1937) is certainly America's most famous female aviator. Earhart's dedication to flight and to improving opportunities for women pilots, as well as her own lengthy list of firsts, is memorialized in the "Pioneers of Flight" exhibit on the museum's second floor. The centerpiece of the display is the bright red, 27-foot, single-engine Lockheed

NATIONAL AIR AND SPACE MUSEUM

Vega that Earhart used in 1932 to become the first woman to fly solo across the Atlantic. Later that year in the same plane, she became the first woman to fly nonstop across the United States. The flight from Los Angeles, California, to Newark, New Jersey, took 19 hours and 5 minutes.

Earhart went on to set more records, including becoming the first person—man or woman—to fly solo from Honolulu to the U.S. mainland. Tragically, in July 1937, Earhart disappeared over the Pacific, along with her navigator, while attempting to become the first woman to make an around-the-world flight. Her plane was never recovered.

✔ **Location:** Jefferson Dr. at 6th St., SW (east end of the Mall)
Metro: L'Enfant Plaza
Phone: 202/357-2700;
TDD: 202/357-1729
Hours: 10 am-5:30 pm, daily
Amenities: audio tours, special programs and events, planetarium, theater, gift shops, cafeteria, automated teller machine

Next to Earhart's Lockheed Vega is a glass case with the leather flight jacket she wore on many flights. In the same case are her goggles, a radio receiver, an American flag she took with her as a passenger on the *Friendship* in 1928, and the Society of Woman Geographers flag she took on at least one flight.

In the letter she wrote to her husband before her last flight, Earhart summed up her credo: "I want to do it because I want to do it. Women must try as men have tried; when they fail, their failure must be but a challenge to others."

Other Notable Pilots

In the same exhibit with Earhart's plane is the tiny red, white, and blue Extra 260 flown by **PATTY WAGSTAFF** in 1991 when she became the first woman U.S. National Aerobatic Champion, a title she held for the next two years.

To win the competition, Wagstaff performed more than 40 maneuvers, including the snap roll, a quick 360-degree, high-speed, stalled roll, and the rolling 360-degree circle, a full turn on its axis while continually rolling. Wagstaff's flight suit, medals, and trophy are also on view.

From an earlier period of U.S. history, record-setting women pilots are featured on a poster in the "Early Flight" exhibit on the first floor. In 1910, **BLANCHE STUART SCOTT** was the first woman in America to fly solo—even though it was only 40 feet. In 1911, **HARRIET QUIMBY** became the first American woman to receive a pilot's license and to fly across the English Channel.

Next to this poster is another on historical flight suits, including Quimby's trademark purple satin suit and **MATILDE MOISANT**'s thick, tweed jumpsuit that saved her life by insulating her from flames after her plane crashed in 1912.

Also on the first floor, the "Golden Age of Flight" exhibit on the 1930s includes information about women aviators who flew races and exploratory flights and set flying records. **JACQUELINE COCHRAN,** for example, held more speed, altitude, and distance records than any other flyer, man or woman, in aviation history. In 1937 alone, she set three major flying records.

On the second floor, the "World War II Aviation" exhibit includes a display on the WASPs—Women Air Forces Service Pilots—who were the

first women to serve America as pilots during a war. This program to free male pilots for combat duty had two parts: one for experienced pilots who performed ferrying and other utility services, and one for training new pilots, which was led by Jacqueline Cochran.

A uniform dress and photographs commemorate the 1,074 women who together logged 60 million miles in the air. Thirty-eight women lost their lives in this service to their country.

A more recent notable woman pilot is featured in an exhibit on the first floor. Suspended from the ceiling near the museum's Independence Avenue entrance is the aircraft *Voyager,* in which **JEANA YEAGER** was copilot with Dick Rutan on the first nonstop, nonrefueled flight around the world. Yeager also helped build the plane for their record-breaking nine-day flight in 1986.

Women in Space Flights
In 1978, NASA selected six women to become the first women to train for space missions. The "Space Race" exhibit on the museum's first floor includes four of those six, along with one civilian woman.

SALLY RIDE (1951-) was the first American woman in space. An astrophysicist, Ride became a NASA mission specialist and, in 1983, participated in the mission aboard *Challenger* space shuttle STS-7. Ride's two-piece blue uniform is displayed in the exhibit. At her request, the name tag simply reads "Sally."

One year later, Ride participated in another mission that was historic, this time for having two women on board. The second woman, **KATHRYN SULLIVAN** (1951-), became the first woman to walk in space during the mission. Sullivan spent 3 1/2 hours outside the shuttle conducting a satellite refueling test. Her space gloves are displayed in the same case as Ride's materials.

SHANNON LUCID (1943-), the only woman to be awarded the Congressional Space Medal of Honor, holds the American record for the most days in space. In the summer of 1996, she returned to earth after spending 188 days on board the space station *Mir* as part of a combined U.S.-Russian project.

America's worst space disaster occurred when the shuttle *Challenger* exploded shortly after take-off on January 28, 1986, ending the lives

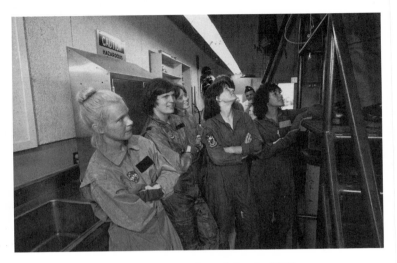

Women astronauts in training in 1978:
(left to right) Margaret Seddon, Kathryn Sullivan, Anna Fisher,
Sally Ride, Shannon Lucid (obscured), and Judith Resnik

of two women and five men. Astronaut **JUDITH A. RESNIK** (1949-86), a mission specialist, was on her second space mission. New Hampshire high school teacher **CHRISTA McAULIFFE** (1948-86) was the first private citizen to participate in a space mission. She had beaten out 10,000 applicants to win her spot and was planning to give lessons from space. The display includes a photograph of crew members, a crew patch, and a flag.

In addition to the permanent exhibits, the museum hosts special exhibits, programs, conferences, and many other events. Flight and space films are also shown regularly in the popular IMAX theater, designed to give viewers the feeling of being in the scene themselves.

See also: on Earhart, pp. 12, 106.

The National Gallery of Art contains one of the world's great collections of Western art from the 13th to the 20th centuries, including many significant works by women artists. The massive collection numbers almost 100,000 items, including about 6,000 paintings and sculptures.

are displayed in chronological order on the main floor of the West Building. Many other works are exhibited elsewhere in the West Building and throughout the East Building, which houses the 20th-century collection. Because the gallery can only display a portion of its permanent collection at any one time, many works are held

NATIONAL GALLERY OF ART

Housed in two buildings, the most notable pre-20th century works

Location:
Constitution Ave.
between 3rd and 7th
Sts., NW
Metro: Archives or Judiciary Square
Phone: 202/737-4215;
TDD: 202/842-6176
Hours: 10 am-5 pm, Mon.-
Sat.; 11 am-6 pm, Sun.
Amenities: tours, lectures, films, concerts, self-service computer information center on the main floor of the West Bldg., cafe, cafeteria, gift shops in both buildings, library use by appointment (call 202/842-6511)
Web site: www.nga.gov

in storage. Depending on the time of your visit, works named here may or may not be on display.

Some of the earliest works by women in the collection are by **JUDITH LEYSTER** (1609-60), **ELISABETH VIGÉE-LEBRUN** (1755-1842), and **ANGELICA KAUFFMANN** (1741-1807).

Leyster was a painter—and a woman—ahead of her time; in her *Self Portrait* (1630), she portrays herself as a confident young artist. The only woman member of the Dutch painters' guilds, Leyster earned a living from her trade—quite a feat at a time when women could not receive formal art instruction.

Vigée-Lebrun earned her reputation as a French court painter, most

notably to Marie Antoinette. Her *Portrait of a Lady* (1789) reflects the political unrest of the period. In addition to showing tension on the woman's face, the artist has dressed her subject in an elaborate costume representing three different cultures to illustrate how politics affected daily life.

Like Vigée-Lebrun and most other early female painters, Angelica Kauffmann learned to paint from her artist father. Kauffmann, one of two women founders of the British Royal Academy, dared to paint historical scenes—traditionally a male artist's domain—and was so successful that she was able to purchase her own home. When on display, Kauffmann's *Franciska Krasinska, Duchess of Courtland,* like works by Leyster and Vigée-Lebrun, may be found on the main floor in the West Building.

The museum also houses works by **MARY CASSATT** (1844-1926) and **GEORGIA O'KEEFFE** (1887-1986). An American who spent most of her life in France, Cassatt was known in the Impressionist movement for her delicate brush strokes and her effects with light. The National Gallery has about a dozen of her paintings, including *The Boating Party* (1893-94), *The Loge* (1882), and *Little Girl in a Blue Armchair* (1878). Cassatt is also known for her printmaking techniques, exemplified in *The Fitting* (1890-91) and *In the Omnibus* (c. 1891). Her paintings are displayed on the main floor of the West Building.

Although O'Keeffe's work encompasses many different styles, she is best known for her mesmerizing portrayals of nature, especially her paintings of flowers. She bequeathed nine of her works to the National Gallery, including the six-part Jack-in-the-Pulpit series, which depicts a magnified view of a flower with increasing detail and abstraction. The final painting in the series is of a haloed black pistil with a backdrop of black, purple, and gray. O'Keeffe's works are located on the upper level of the East Building.

Other female artists represented in the collection include:

BERTHE MORISOT (1841-95), like Cassatt an Impressionist artist, primarily painted women and children, often drawing upon family members as subjects. Her works in the museum include *The Artist's Sister at a Window* (1869) and *Girl in a Boat with Geese* (c. 1889).

German artist **KÄTHE KOLLWITZ** (1867-1945) expressed her feelings about the horrors of war and the plight of the poor in etchings and sculpture. The gallery has more than 160 of her works. Her etchings can be viewed in the print study room by appointment.

ALMA THOMAS (1891-1978), an African-American painter, spent most of her life in Washington, D.C., and developed a talent for abstract art in her 60s. Thomas graduated from Howard University as its first art major, then taught art at Shaw Junior High School for 35 years while also exhibiting her works. Thomas was inspired to create colorful, abstract images as viewed from the window of her Washington townhouse.

LOUISE BOURGEOIS (1911-) is a feminist sculptor known for her totemic works alluding to the human body. Her work explores the relationship between man and woman and is said to be inspired by early traumas in her life. The museum owns *Spring* (1949) and *The Winged Figure* (1948, cast 1991).

Abstract expressionist **HELEN FRANKENTHALER** (1928-) uses conceptual shapes in a splendid blend of color and serenity to depict the natural world. Frankenthaler is the inventor of the "soak-stain" technique, which introduced a new texture to the art world and an entirely new way of

IN THE WORDS OF Georgia O'Keeffe (c. 1939)

"Nobody sees a flower—really—it is so small— we haven't time—and to see takes time like to have a friend takes time. If I could paint the flower exactly as I see it no one would see what I see because I would paint it small like the flower is small. So I said to myself—I'll paint what I see—what the flower is to me but I'll paint it big and they will be surprised into taking time to look at it—I will make even busy New Yorkers take time to see what I see of flowers."

applying paint. Her works in the museum are *Wales* (1966) and *Gateway IX* (1988).

EVA HESSE (1936-70), a sculptor, experimented with such new materials as latex and fiberglass. Although she died at 34 of a brain tumor, Hesse's innovations were enormously influential in the art world. The collection includes one of her last pieces, *Test Piece for Contingent* (1969), made of latex over cheesecloth.

Painter and sculptor **NANCY GRAVES** (1940-95) used science—anthropology, archaeology, biology, and taxidermy—as a foundation for expression. Her pieces in the collection include *Unending Revolution of Venus, Plants, and Pendulum* (1992), a bronze, brass, stainless steel, enamel, and aluminum work, and *Spinner* (1985), which is made of

bronze, glass, enamel, and polychrome patina.

LYNDA BENGLIS (1941-) is a sculptor known for her twisted metallic knots and totemic figures. The collection includes five of her works, including *Fool* (1980) and *Pour Daum* (1979), both created with plaster, bronze wire, and gold leaf.

Other women artists in the collection include **LEE KRASNER, LOUISE NEVELSON, JOAN MITCHELL,** and **SUSAN ROTHENBERG.**

See also: on Leyster, p. 98; on Vigée-Lebrun, p. 98; on Kauffmann, p. 98; on Cassatt, pp. 38, 98, 105; on O'Keeffe, p. 39; on Morisot, p. 99; on Kollwitz, p. 101; on Thomas, pp. 96, 101; on Bourgeois, pp. 39, 95; on Frankenthaler, pp. 95, 101; on Krasner, pp. 95, 101; on Nevelson, pp. 39, 94-95, 101; on Mitchell, p. 95; on Rothenberg, p. 40.

Among the most intriguing works in the National Museum of African Art are the large, motorized figures created by Nigerian sculptor **SOKARI DOUGLAS CAMP** (1958-). In Camp's Kalabari culture, she broke through two barriers: she established herself as an artist although that field the works of a tribal sculptor and later educated in California and London—uses her work to share information about her people and her experiences as a Nigerian woman.

Prominent in the museum's collection are Camp's figures representing an "Alali" or festival. Clad in traditional Kalabari clothing, these

NATIONAL MUSEUM OF AFRICAN ART

is traditionally reserved for men; and she created sculptures as art although her culture considers such works to be for religious or ceremonial purposes only, not art per se. Camp, however—inspired at a young age by

✓ **Location:**
950 Independence Ave., SW (directly behind the Smithsonian Castle)
Metro: Smithsonian
Phone: 202/357-4600;
TTY: 202/357-4814
Hours: 10 am-5:30 pm, daily.
Library hours: 9 am-5:15 pm by appointment only (call 202/357-4600, x286)
Amenities: gift shop, tours

larger-than-life pieces made of steel and other materials show the rhythm and passion of the culture and the significance of rituals. *Iriabo (Clapping Girl)* (1987) is a young female dancer who figures prominently in festivals. Her body wrapped in valuable cloth with coral beads at her hips, arms, and legs, Iriabo (which means prized woman) dances, via motorization, at intervals. Another dancing festival figure, *Masquerader with Boat Headdress* (1987), wears white ceremonial attire and headdress and holds a rod in each hand.

In addition to depicting ceremonies, Camp sees her art as an extension of her personal experience, especially reflecting women's role

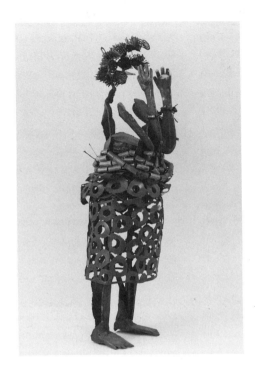

Iriabo *by*
Sokari Douglas Camp

caring for the household. "The women, when I was small, were very 'handy,'" she told a Smithsonian audience before her 1988 exhibition. "I find myself preparing things in my work as if I am making the things that I've seen women make. I am forever binding my stuff, cutting it into little bits, and fixing it into something else. I think my art has to do with cooking or cleaning the house."

Camp's sculptures are just some of the works in this museum's collection that illuminate the lives of women in different parts of Africa. Although most of the works are by men or unidentified artists, visitors can learn a great deal from them about the role of women in African societies and cultures.

The first-level exhibit "Images of Power and Identity" includes cultural symbols of female beauty, womanhood, and motherhood. One figure, the *Blolo Bla* of the Baule peoples, is a standing woman with strong calf muscles, elongated and rounded proportions, and scarification; she has beads around her neck, waist, and ankles. The figure symbolizes a man's spirit mate from the "other world."

Another sculpture, carved in the late 1800s possibly by an artist of the Mende peoples of Sierra Leone, is of a young woman standing with one hand on her breast. Also on display are standing and kneeling small ivory female figures with waist beads and jewelry from the Yoruba peoples.

Motherhood is exemplified by the large woman and child figure from the M'bembe peoples of Nigeria. This wood carving is of a seated woman with a leopard claw necklace around her neck and a child across her knees. The carving, one of the few surviving of its kind, was once part of a huge gong that was used in village ceremonies.

Sculptures of women figures were commonly created for African social and religious ceremonies, such as initiations, and were often used as offerings to the gods. At the entrance to Room Two is a large wood sculpture of a kneeling woman balancing on her head a drum used in initiation ceremonies. Created by an artist of the Baga peoples of Guinea in the 1920s, this figure's hip bands and crossed torso straps show that she has been initiated into womanhood.

Another ceremonial statue is of a kneeling female figure with one hand on her mouth. The figure, carved by a Baule artist, is made of wood and covered in gold overlay, showing that it was an item of great prestige. The female form was also commonly used as a link to a higher being, as exemplified by the wood carving of the female figure and children of the Yoruba peoples, originally displayed in a shrine. This female devotee of the gods holds a bowl in a gesture of offering.

Also in the exhibit are masks, some of which depict the idealized woman of various cultures. The Chokwe mask is of a young woman's face with prominent forehead, large eyes, and a small nose. The mask was worn by male dancers in public ceremonies, including initiation rites. Another by the Punu peoples displays feminine attributes; it was used in ceremonies to symbolize the afterlife and the spirits of the dead.

The permanent collection of the museum contains more than 7,000 works exhibited on a rotating basis. The museum is still being developed as the national collection of African art, representing the vast continent's more than 900 distinct cultural groups.

To learn more about African culture, visitors can make an appointment with the research library or the photographic archives for the visual arts of Africa.

No one location in Washington offers more to see and learn about women in times past than the National Museum of American History. Exhibits document the role of our nation's first ladies; the back-breaking domestic chores of 18th-century women; women's contributions to improved important job of sewing the 42-foot banner, designed to hang prominently at the fort.

The daughter of a flagmaker, Pickersgill learned her craft from her mother. According to the Star Spangled Banner Flag House, the current museum site of her Baltimore home, Pickersgill bought the house

NATIONAL MUSEUM OF AMERICAN HISTORY

social conditions; the struggles of black women for equality and economic independence; and advances that affect the lives of women today.

The first historical object visitors see upon entering on the Mall side is the enormous "Star Spangled Banner" hanging vertically on the wall. Now tattered and faded, the flag was made famous by Washington lawyer Francis Scott Key, who wrote the poem that became the national anthem after seeing the flag "still there" over Fort McHenry in Baltimore after a British bombardment during the War of 1812.

The flag was *made*, however, by **MARY PICKERSGILL** (1776-1857), a trusted seamstress given the

as a widow and supported herself and her mother and daughter there on her commissions. In 1802, she organized the Impartial Human Female Society which provided money to widows and abandoned wives, helped them find employment, and gave

 Location: 14th St. and Constitution Ave., NW (west end of the Mall)
Phone: 202/357-2700;
TTY: 202/357-1729
Hours: 10 am–5:30 pm, daily
Amenities: cafeteria, gift shops, audio tours. The museum shop on the first floor offers a comprehensive selection of books on women's history.

53

them a place to live. Pickersgill thus became one of the first women in the United States to establish a charity benefiting women.

The First Ladies Exhibit

One of the museum's most famous exhibits, "First Ladies: Political Role and Public Image" explores the contributions and interests of U.S. presidents' wives. A short video near the exhibit entry on the second floor surveys how first ladies have defined their roles and called attention to important issues. An audio tour offers insights from former first ladies themselves.

The exhibit begins with "Inventing the First Lady's Role," a tribute to the nation's first two first ladies, **MARTHA WASHINGTON** and **ABIGAIL ADAMS**. Items belonging to Washington include a mirror, a mahogany chest, a tea box with mother-of-pearl inlay, and her portrait painted by Rembrandt Peale. Adams's belongings on display include porcelain dinnerware, letters she wrote to her sister, several of her books, and an invitation to dine at the President's House, as the White House was then known.

"The First Lady as the Nation's Hostess" section features such women as **DOLLEY MADISON** and **MAMIE EISENHOWER,** two first ladies who excelled at entertaining. Madison was also known for her Wednesday night socials, when she opened the White House to women of all social classes.

Among the White House china on display in this section is the regal pattern ordered by **MARY TODD LINCOLN,** who was criticized for spending money on furnishings during the Civil War. Another piece of nostalgia, *The White House Book of Etiquette,* outlines rules of conduct for first ladies in 1903.

The next section explores "First Lady as Advocate of Social Causes." **ELEANOR ROOSEVELT** is featured for her work as a social reformer, especially concerning rights for women, minorities, and the poor. A large photograph shows her in a soup kitchen.

IN THE WORDS OF Barbara Bush (1990)

"Someday, someone will follow in my footsteps and preside over the White House as the President's spouse. And I wish him well."

Inaugural gowns in the First Ladies Collection

Others noted in this section are **LADY BIRD JOHNSON** for her advocacy of ecological awareness and her efforts to "beautify" the nation's countryside and neighborhoods, **BETTY FORD** for lobbying for passage of the Equal Rights Amendment, and **HILLARY RODHAM CLINTON** for her work for children and health care reform.

"The First Lady as Political Partner" section includes such milestones as **EDITH WILSON**'s being the first presidential wife to join her husband on an official mission abroad.

One of the most amusing parts of the exhibit is "The First Lady as Campaigner," which contains election memorabilia designed to appeal to women voters. Campaign slogans adorn household items such as thimbles, plates, wash buckets, and napkins. The cheery domesticity of the 1950s seemed to have generated particular enthusiasm for Dwight Eisenhower's campaign: aside from an "Ike Measures Up" measuring spoon in the main display case, a second case contains "I Like Ike" slogans on a dress, campaign jewelry, and even stockings.

The "Using Fashion to Project an Image" section documents first ladies' personal style. **LOUISA CATHERINE ADAMS**'s fur cape is displayed, alongside tiaras and evening purses owned by Edith Wilson and Mary Todd Lincoln.

Finally, "The Job of the First Lady in the 20th Century" focuses on political use of the media. Visitors can listen to the radio addresses of Eleanor Roosevelt and **LOU HOOVER,** both of whom used that then-young medium to convey their messages. A gallery featuring print media from the second half of the century includes *Millie's Book,* in which **BARBARA BUSH**'s brown and white spaniel, Millie, "tells" about her life in the White House. Proceeds from book sales went to Bush's literacy projects.

The exhibit's visual highlight, of course, is the ever-popular First Ladies Collection of clothing. The first group, worn by first ladies in the early 1800s, is shown in a room dimly lit to help preserve the dresses. One of the more spectacular gowns is an open robe style of embroidered ivory satin with a high waist and narrow back; it was worn by Dolley Madison. Another, worn by Mary Todd Lincoln, is made of silk striped taffeta with brocaded purple flowers. Renowned photographer Mathew Brady took Lincoln's picture wearing this dress.

A large poster at the entrance to the gallery explains that the term "first lady" did not come into popular use until the mid-19th century. The wife of the first president was called Lady Washington. The next wives were called Lady Presidentess, Mrs. President, or simply Mrs. The first use of the term is believed to have been at Dolley Madison's funeral in 1849, when President Zachary Taylor eulogized her as "truly a first lady for a half-century."

In the second gallery, which has subdued lighting, are a green Chinese robe worn by **HELEN TAFT,** a sparkling sequined gown worn by **FLORENCE HARDING,** a grey and silver day cocktail suit worn by **JACQUELINE KENNEDY,** and a red pin-striped power suit worn by **NANCY REAGAN.** Also found there is Mamie Eisenhower's bright red evening gown,

Down the hall to the left, the third gallery displays evening gowns worn by recent first ladies. With the exception of Betty Ford's (whose husband, Gerald, did not have an inauguration because he took office midterm), all the dresses were worn to inaugural balls.

Included are the white one-shoulder beaded gown worn by Nancy Reagan in 1981, the stunning

violet gown Hillary Rodham Clinton wore in 1993, and the royal blue satin and velvet gown worn in 1989 by Barbara Bush, along with her trademark triple strand of pearls.

Suffrage and Other Causes

Also on the second floor, the "From Parlor to Politics" exhibit chronicles the instrumental role women played in the Progressive Era (1890-1925), when significant changes occurred regarding child labor, women's right to vote, public health, education, alcohol consumption, and living and working conditions for the poor.

The exhibit proceeds through various types of women's activities—from gathering in small groups in their homes, to forming women's clubs and national networks, to becoming a public catalyst for political and social change.

Visitors can listen in to a recorded discussion in which a group of women in a parlor discuss club business, including a newly made banner to carry in a suffrage march. A kitchen display shows how women found ways to perform their domestic duties more efficiently to gain time to work for social change.

Included in this kitchen display are such innovations
of the time as cookbooks, packaged foods, and a telephone.

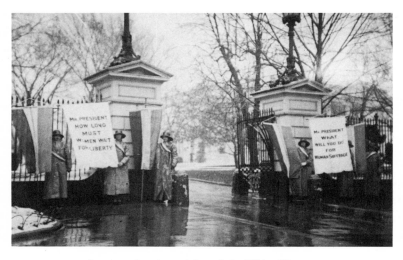

Some suffragists picketed the White House,
carrying signs with pointed messages.

Also on exhibit are ribbons and badges from the women's club movement. Most clubs were started for social purposes, but eventually directed their energies into community and school improvement.

In a nearby display case are banners, quilts, and other memorabilia representing the temperance movement against saloons and alcohol. Many women of the time took on the cause of prohibition because they believed men who drank alcohol were taking time and money away from their families. The foremost temperance organization was the WCTU, the Women's Christian Temperance Union, founded in 1874. One of the most vivid images of the movement is that of the militant **CARRY NATION** (1846-1911), who was often pictured—as in the image in the display—wielding a hatchet with which she destroyed saloons.

The next part of the exhibit tells of dedicated women who worked to improve conditions for underserved groups in their home communities.

NANNIE HELEN BURROUGHS (1878-1961) was a Washington, D.C., educator who, in 1909, founded the National Training School for Women and Girls to give single African-American women

liberal arts education, housing, and vocational skills. Her desk, chair, and typewriter are on display, along with pictures of famous Americans like Frederick Douglass and **HARRIET BEECHER STOWE** which she hung at the school to encourage her students to excel.

MARY BRECKINRIDGE (1881-1965), a nurse-midwife from Kentucky, returned from serving in the American Red Cross in France during World War I to found the Frontier Nursing Service in the Appalachian mountains. With outposts ten miles apart, Breckinridge traveled first on horseback and later in jeeps to deliver medical care. Her care for pregnant women resulted in a substantial decrease in deaths from childbirth. On display are her saddle bag and medical supplies.

Another section of the exhibit not to be missed is "Votes for Women." On display is the suffrage wagon **LUCY STONE** (1818-1893) took on a tour of the northeast to promote a constitutional amendment giving women the right to vote. The wagon is emblazoned with slogans; on its back are listed the states, most of them in the West, that had already adopted suffrage amendments.

Across the aisle from the suffrage wagon is a display of an in-home suffrage office with the inspiring words of **SUSAN B. AN-THONY**—"Failure is Impossible"—inscribed at the top. The exhibit includes a wooden desk used by Anthony and **ALICE PAUL**. Also displayed are photographs; a copy of *The Revolution*, a suffrage newspaper, owned by Anthony and **ELIZABETH CADY STANTON**; and the multivolume *History of Woman Suffrage*, written by Anthony, Stanton, and **MATILDA JOCELYN GAGE**.

IN THE WORDS OF Lucy Stone (1855)

"The flour-merchant, the house-builder, and the postman charge us no less on account of our sex; but when we endeavor to earn money to pay all these, then, indeed, we find the difference."

—from Elizabeth Cady Stanton, Susan B. Anthony, and Matilda J. Gage, eds., *History of Woman Suffrage*, Vol. 1 (1881)

The final part of the exhibit presents information on Chicago's legendary Hull House, which was founded by **JANE ADDAMS** (1860-1935) and **ELLEN GATES STARR** (1859-1940) as a settlement in a poor, immigrant neighborhood. Their idea was that reformers could study living conditions, wages, labor, and health in a neighborhood where changes were needed most. On display are the house's mailbox featuring names of reformers who stayed there, Addams's silver lorgnette and peace brooch, and photographs of activities at the house.

Reformers at Hull House were responsible for labor legislation for women and children and juvenile courts, as well as convincing the U.S. Department of Labor to establish women's and children's bureaus. Part of Addams's theory was based on a comparison of cities and homes. As she explained, "A city is in many respects a great business corporation, but in other respects it is enlarged housekeeping. . . . May we not say that city housekeeping has failed partly because women, the traditional housekeepers, have not been consulted as to its multiform activities?"

Outside the Hull House section, across from the suffrage wagon, is a small display case containing, among other objects, Addams's Nobel Peace Prize. The medal was awarded to Addams in 1931 for her work toward international peace and social justice. She was the first woman to receive the peace prize.

Elsewhere in the Museum

For a glimpse into women's lives in late 18th-century America, visit the "After the Revolution" exhibit on the second floor.

The exhibit features household and other objects from families in different types of communities. These include a farm woman in Delaware, a slave woman at Mount Vernon, a Native American woman of the Seneca Nation in New York, and a widow who became a merchant in Massachusetts.

The section on the city of Philadelphia includes a display on women shopkeepers and seamstresses. A placard notes that the city directory of 1800 included many women seamstresses and tavern-keepers and one each female blacksmith, cooper, coachman, and printer.

A related display on childbirth is particularly vivid. In the late 1700s, women approached childbirth with apprehension because it often meant suffering and death for the mother, the newborn, or both. The display contains a primitive obstetrical kit (with forceps and perforator), a nursing bottle with a bone nipple, and a box of Hoopers Female Pills used for maladies ranging from hemorrhoids to indigestion.

The "Field to Factory: Afro-American Migration, 1915-40" exhibit (also on the second floor) documents the experiences of hundreds of thousands of African-Americans who left the South in search of better opportunities in the North. One section shows on a large map some typical routes taken by these migrants and presents aspects of their lives.

For example, **LILLIAN REUBEN-McNEARY** was the teenage daughter of a South Carolina sharecropper in the early 1930s. She dreamed of becoming a nurse, but knew she could never train for that profession in the South, so one day young Lillian took a bus, alone, to New York City. She encountered racism along the way, but found work in the city as a live-in nanny, earning $6 per week. With only Thursday evenings and Sundays off, she had no time to attend school, so she commuted to White Plains, New York, on her free time to receive instruction from an aunt living there. After several years, she entered a church-sponsored nursing school program and earned her long-awaited certification.

Another part of the exhibit shows how some black women gained economic independence by means of beauty salons.

On display is a spartan salon owned and operated by **MARJORIE STEWART JOYNER** in the early 1900s. Joyner's mentor was **MADAME C. J. WALKER,** the renowned entrepreneur of health and beauty products for black women. Although the hours were long, Joyner was able to run her own business and earn a living as an independent woman.

Finally, inside the museum's Science in American Life exhibit on the first floor is a section called "Better Than Nature: The Pill." This display explains how this important form of contraceptive was developed and how its use evolved over time.

The key individual in the process was **MARGARET SANGER** (1879-1966), a nurse whose life-long commitment to birth control was motivated by her own mother's death at 49 after bearing 11 children. As a nurse, Sanger often cared for poor women, weakened like her mother by too-frequent pregnancies. As a consequence, after traveling to Europe in 1913 to learn about birth control techniques, she opened in Brooklyn, New York, the first birth control clinic in the country and began demonstrating the use of diaphragms.

In her effort to launch a working-class birth control movement, Sanger also published a newspaper, the *Woman Rebel*, and a pamphlet on birth control. After Sanger was arrested and jailed for distributing birth control information—then considered obscene—through the mail, she challenged her case in court on constitutional grounds and won. As a result of those efforts, she became convinced of the need for support from both the middle classes and the medical profession. The organization she founded for that purpose later became Planned Parenthood.

Later in her life, Sanger raised money to fund research into better contraceptives. These efforts, which led to the Pill, are the focus of the exhibit. Among the displays is one of packaging techniques designed to help women remember to take their pills daily. Reliable, easy-to-use birth control was a key development in women's history, for it increased women's ability to make their own decisions about families and careers.

Where to Start?
With so much to see and learn in this museum, the first step for any visitor should be the information desks near both entrances. Guides there can provide maps of the three floors and directions to exhibits of interest.

See also: on Washington, pp. 68, 109, 113, 121, 122, 132-34; on A. Adams, pp. 19, 112, 113; on Madison, pp. 89, 104, 110-11, 112-13, 114, 121; on Eisenhower, p. 113; on Lincoln, pp. 113, 120-21; on Roosevelt, pp. 35-37, 85-86, 106, 112, 115, 138; on Johnson, pp. 112, 115; on Ford, pp. 112, 113; on Clinton, 26, 112, 113, 115; on Wilson, 110, 113; on L. Adams, 114; on Hoover, p. 115; on Bush, pp. 112, 113; on Taft, pp. 118, 126; on Kennedy, pp. 113, 114, 115, 125-26; on Reagan, pp. 112, 113, 115; on Burroughs, p. 11; on Stowe, pp. 107, 122; on Breckinridge, p. 112; on Anthony, pp. 8, 12, 17, 19, 21, 82, 104, 122; on Paul, pp. 16-20; on Stanton, pp. 8, 17, 19, 21, 104-5, 122; on Addams, p. 104; on Sanger, pp. 12, 106.

Among the myriad displays of fossils, rocks, plants, insects, stuffed and live animals, and anthropological artifacts in the National Museum of Natural History are exhibits showing the rugged lives of Native American and Eskimo women in the 19th century. Dioramas and exhibited items reveal much about how these women spent their time and the challenges they faced in living off the land.

Dakotas and Kiowa women who lived in Oklahoma; samples are displayed along with jewelry. Also on display are pouches, moccasins, and leggings featuring small glass beads, known as seed beads, that Indian women embroidered in intricate patterns on many items. This beadwork tradition continues today.

NATIONAL MUSEUM OF NATURAL HISTORY

reveal much about how these women spent their time and the challenges they faced in living off the land.

"Native Cultures of the Americas," on the first floor, includes clothing, jewelry, crafts, and cooking utensils used by women of the Cherokee, Sioux, and Seminole tribes. One skirt, made of shredded cedar bark, was worn by a Naskapi woman, along with such winter clothing as a fur-lined dress, leggings, and moccasins. One colorful, two-piece dress worn by a Seminole woman has a ruffled bare midriff and a full skirt; another has a long cape over a blouse and skirt. Dresses made of buckskin and adorned with colorful beads were worn by Sioux women from the

The exhibit also contains items for food preparation, the activity that

 Location: Constitution Ave. between 9th and 12th streets, NW
Metro: Smithsonian and Federal Triangle
Phone: 202/357-2700; TTY: 202/357-1729
Hours: 10 am-5:30 pm, daily; closed Dec. 25.
Discovery Room open Tues.-Fri, noon-2:30 pm and Sat.-Sun., 10:30 am-3:30 pm.
Amenities: gift shops, guided tours of exhibit highlights at 10:30 am and 1:30 pm Mon.-Thurs. and at 10:30 am Fri.
Web site: www.nmnh.si.edu

consumed much of an Indian woman's life. Items include a hominy sieve, corn mill, harvesting basket, and Chippewa wooden yoke, which women placed across their shoulders to carry buckets of sap.

A rare glimpse into the lives of the Plains Indians is provided by the part of the exhibit featuring one of the few remaining tipis of that culture. Several women were needed to make the covering for the tipi, which was the year-round home to many Indians before 1875. After laying out 14 buffalo skins and fitting them together into a half circle, the women sewed the skins together with sinew (buffalo tendons) and used porcupine quills for decoration. The tipi weighed about 100 pounds and required two horses to transport it.

Next to the tipi is a diplay showing women as weavers. Women made Chilkat blankets out of mountain goat wool, then dyed the wool black by soaking it in a mixture of urine and hemlock bark. These blankets were traded for food and other necessities.

Living in the upper regions of North America, Eskimo women faced the year-round cold with few natural resources. Designated the clothing makers for their families, women treated and stretched animal skins that would provide warmth in the frigid temperatures. The display shows a woman stretching a hide on an upright driftwood frame to dry and scraping it to remove bits of flesh. On display are skin scrapers, stone knives used to cut and shape the skins, and bodkins, or daggers, to punch holes in them. The women sewed hides together using bone needles and dried caribou sinew as thread, often after chewing the skin to soften it. On view is a warm, head-to-toe woman's outfit made entirely of squirrel skins.

Exhibits elsewhere in the museum feature women of Micronesia, including neck cords worn by girls of Yap island after reaching puberty. A short woven skirt represents those worn by girls in Fiji; as they grow older, they wear gradually longer skirts. A display including a headdress, barkcloth bag, elegant head sash, trinkets, and women's armor demonstrates Indonesian women's skill at weaving, sewing, and pottery.

Other exhibits show a Pakistani nomad tent surrounded by life-size photographs of women and the activities they performed in camp; a woman of Mesopotamia separating wheat from chaff; women of New Zealand pounding raw flax for textiles; and Samoan women making kava for tribal ceremonies.

The United States Holocaust Memorial Museum tells the story of the persecution and systematic murder of six million Jews and five million others in Europe between 1933 and 1945; approximately half of those killed were women and children. Here, visitors will learn about the worst that women period's main events and themes, and concluding with the effects and aftermath.

After entering the museum on the 14th Street side, visitors begin their self-guided tour of the permanent exhibition on the fourth floor, then proceed through the third floor, and conclude on the second floor.

UNITED STATES
HOLOCAUST MEMORIAL MUSEUM

have ever endured—but will be inspired as well by the profound courage of both those who survived and those who did not. This is not a museum to drop by for a brief run-through, but the unforgettable experience it offers is well worth the few hours required. In fact, the museum—which opened in 1993—attracts a huge crowd of visitors each day, second in number only to the National Air and Space Museum.

The permanent exhibition is designed as a progressive educational experience and is thus arranged in chronological order. It begins with the buildup to the Holocaust, followed by a presentation of the

Location:
1000 Raoul Wallenberg Pl., SW (14th and Independence)
Metro: Smithsonian
Phone: 202/488-0400;
TDD: 202/488-0406
Hours: 10 am-5:30 pm, daily. Passes to see the permanent exhibition are available starting at 10 am; lines to acquire passes usually start forming much earlier.
Amenities: cafe, shop, special programs including lectures, films, seminars, and concerts; ask for a calendar at the information desk
Web site: www.ushmm.org

4th Floor:
The Nazi Assault (1933-39)

On this floor, informational panels, photographs, and archival films and documents begin the story of how the Nazis came to power in Germany and fostered an environment that supported their methodical deprivation of specific groups' rights, dignity, and means of livelihood.

Among objects displayed in large exhibit cases are items of clothing worn by women who were later taken to concentration camps. Their passports and identification cards are also on display. A large, compelling photograph shows a group of women in Poland being led through the woods to their execution.

Also note an oversized photograph of a non-Jewish woman being publicly punished. A sign has been placed around her neck saying that she married a Jew and was, in terms of Nazi propaganda, "defiling the German race."

A small exhibit is on Roma, or gypsies, most of whom were women and children. Roma were persecuted for their low social status even before the Holocaust began. On view are combs owned by a Roma woman who was forcibly sterilized, a common Nazi practice for people they

deemed undesirable. Other Roma items include clothing, jewelry, and a family wagon.

This floor also includes the "Tower of Faces," a montage of 1,200 photographs of people from the Polish town of Ejszyszki. These photographs were gathered over the course of 14 years by **YAFFA ELIACH,** a Jewish woman who was one of only 29 survivors out of the 3,500 Jews in the town before the Nazi slaughter. As in Ejszyszki, the Jewish populations of many towns in eastern Europe were completely or near-completely eliminated during the Holocaust. In Poland as a whole, of the estimated pre-Holocaust Jewish population of 3.3 million, 3 million were killed.

3rd Floor:
The Final Solution (1940-44)

Ghetto and concentration camp life are presented on this floor. Objects range from personal articles like combs, food bowls, and shoes to a scale model of a gas chamber.

Also on view is a large photograph of hundreds of women with their heads shaved, one of the numerous ways women in concentration camps were robbed of their femininity. Women in or on the way to camps

were routinely brutalized and were so malnourished over long periods of time that they stopped menstruating.

As a result of their harsh treatment, many women who survived were later unable to bear children or did so only with great difficulty and risk. It is partly because of this challenge to women's ability to procreate that the children of survivors are so cherished—as well as so valued as a triumph over the Nazis' efforts to abolish a population.

In spite of conditions that led to the disfigurement and death of so many, stories of women helping each other during this time are among the most inspirational of any found in history.

One example is on the wall of photographs of new arrivals to Auschwitz; this wall is opposite an actual German rail car used to transport Jews to concentration camps. On the lower right side of the wall is a picture of a grandmother in a head scarf holding her grandson, Danny.

The grandmother had deliberately taken Danny from her daughter, knowing that women with children faced certain execution. By doing so, she saved her daughter's life. Tragically, however, shortly after this photo was taken, grandmother and grandson were executed. The grandmother's other daughter tells this story in the film at the end of the tour, saying that her mother's last words to them were for the sisters to take care of each other.

Among many other notable images on this floor, the **ANNE FRANK** display recalls this famous Jewish girl who came of age during her years hiding with her family in an Amsterdam attic. After the family was discovered, they were sent to Bergen-Belsen concentration camp. Anne died there of typhus only four weeks before liberation. For generations, this young woman's diary has been the means by which millions of readers all over the world have been introduced to the Holocaust.

IN THE WORDS OF Anne Frank (1944)

"Every day I feel myself maturing, I feel liberation drawing near, I feel the beauty of nature and the goodness of the people around me. Every day I think what a fascinating and amusing adventure this is! With all that, why should I despair?"

Hannah Senesh in Palestine, c. 1943

The "Voices of Auschwitz" section, also on this floor, is a room with constantly playing audiotapes of Holocaust survivors, including many women, telling about their experiences in this concentration camp.

2nd Floor:
The Aftermath (1945-present)

Part of this floor honors, through photographs and stories, more than 10,000 people—both Jewish and non-Jewish—who risked their lives to save Jews during this time. Some of the women heroes include:

• Poet **HANNAH SENESH** was one of 35 Jewish parachutists from Palestine who were dropped into Hungary in 1944 to organize a revolt there. Senesh, a native Hungarian from Budapest before she immigrated to Palestine, was captured, tortured, and executed. Her last poem read: "I could have been 23 next July;/I gambled on what mattered most;/The dice were cast./I lost."

• **SOPHIE SCHOLL** was a member of "White Rose," a group of university students who opposed Nazism. On February 12, 1943, she was executed for her activities.

• **ADELAIDE HAUTVAL,** a health care worker who publicly protested the treatment of Jews, was sent to Auschwitz where she saved the lives of many prisoners who contracted typhus.

• **IRENE GUT OPDYKE,** a housekeeper, risked her life to hide Jews in the villa of the German army major who employed her. When the major discovered what she was doing, she agreed to become his mistress in return for his silence.

• Social worker **IRENE SENDLER** smuggled 200 children out of a Jewish ghetto before it was liquidated by falsely stating they were sick. Once discovered, she was arrested and tortured, but just before she was to be executed, the Jewish underground helped her escape.

• **JEANNE DAMON,** headmistress of a Jewish kindergarten in Brussels, helped to find hiding places for 2,000 children.

One of the most emotional parts of the exhibit is at the end, where the film "Testimony" is shown continuously. In this documentary, Holocaust survivors, many of them women, share their experiences.

Resources for Research

For more information about the lives of women during the Holocaust, visit the Learning Center on the second floor. Information is also available there about women in the resistance and in other roles. The library and Registry of Jewish Holocaust Survivors are on the fifth floor.

An extensive selection of books for readers of all ages, videotapes, and other materials is available in the museum shop near the 14th Street entrance.

The creation of the Vietnam Veterans Memorial, familiarly known as "The Wall," is in itself a grand step in history: While reshaping the way the nation views memorials to soldiers, it also transformed a shy, female, college student into an overnight sensation and trailblazer for women architects.

memorial as an exercise in a class. Her simple, yet stark concept—identified as design number 1,026 in the competition—was chosen from 1,421 entries.

Although controversial to some when it was completed in 1982, the memorial quickly became cherished for its ability to generate powerful

THE VIETNAM WAR MEMORIALS

The unique and entirely unconventional monument was designed by **MAYA LIN** (1959-), a 21-year-old architecture student at Yale University, who entered the national design competition after being assigned the

✓ **Location:** Constitutional Gardens, 23rd St. and Constitution Ave., NW
Metro: Foggy Bottom
Phone: 202/634-1568
Hours: 24 hours a day, daily
Amenities: gift shop located at the west end of Constitutional Gardens

emotions in visitors of all ages and nationalities and has now become a tourist favorite.

Lin's simple design consists of two black marble walls that delve into the earth and meet at a 12-foot pinnacle. Carved into the reflective stone are the names of more than 59,000 Americans who died as a result of the war or are missing in action. It was a requirement of the competition to include these names in the design, thus honoring each individual lost. The names, listed in chronological order of death or disappearance, include the names of the eight women who died in the war.

Visitors walk along a narrow pathway parallel to the walls. The pathway inclines downward alongside the first wall of stone, reaches its lowest point where the two walls meet, and then inclines gradually upward by the second.

Relatives and friends of individual soldiers often place commemorative items next to their names. In the 15 years since the wall was dedicated, nearly 54,000 items have been left there. The National Park Service, which oversees the memorial, collects and catalogues the items and places them in climate-controlled storage. Some are displayed in the National Museum of American History.

Although Maya Lin received a grade of B for her design, she now receives the highest accolades from visitors who come to the Wall, find the name of a loved one, touch it, and often cry. By both recreating the emotional atmosphere of the war and honoring each individual lost there, Lin truly touched the heart of the nation and helped visitors understand the myriad roles that a memorial can play in society.

After completing her master's degree in architecture from Yale, Lin is now an architect in high demand. Her other well-known works include the Civil Rights Memorial at the Southern Poverty Law Center in Montgomery, Alabama, and a monument to women students at Yale.

The Vietnam Women's Memorial

Located directly across from the Wall, this memorial is a moving tribute to the 265,000 American women who served their country during the time of the Vietnam War. It honors, specifically, the 11,000 who served in Vietnam—nearly all as nurses, many only in their early 20s. The sculpture is an emotional representation of their strength, compassion, and dedication.

The life-size bronze sculpture features three women. One is seated on a mound of sandbags tending to a wounded soldier. Another is standing, looking upward perhaps in search of a medevac or towards the heavens. The third is kneeling, looking down at an empty helmet. "The kneeling figure has been called 'the heart and soul' of the piece," says its sculptor, **GLENNA GOODACRE,** "because so many vets see themselves in her. She stares at an empty

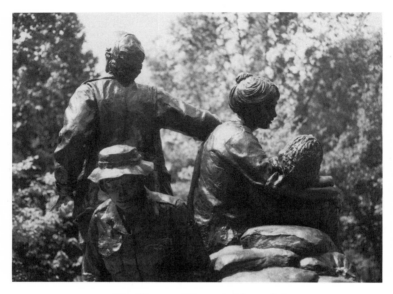

The Vietnam Women's Memorial

helmet, her posture reflecting her despair, frustrations, and all the horrors of war."

The expressions on these three women's faces dramatize their silent pain as they tended to the wounded and dying, day after day.

The memorial was the vision of former U.S. Army nurse **DIANE CARLSON EVANS,** who served in Vietnam in 1968-69. Evans put her own feelings about the war into her poem "Our War," which includes these lines: "I don't go off to war, so they say,/I'm a woman./Who then has worn my boots?/And whose memories are these,/of youth's suffering?/I'm a woman and I've tasted man's war./Our war."

While the names of the eight servicewomen who died in Vietnam are inscribed on the Vietnam Veterans Memorial, Evans and others felt that all the women who served in Vietnam deserved special recognition and that it should be equivalent to the memorial to men as represented in the statue of three servicemen nearby.

In 1984, two years after the Wall was dedicated, Carlson founded the Vietnam Women's Memorial Project. It took nearly a decade to win congressional and federal regulatory agency approvals and to raise the required private funds. Many donations came from the nurses themselves and from Vietnam veterans who were grateful for their service.

On Veterans Day in 1993, the Vietnam Women's Memorial was dedicated as the first memorial in Washington, D.C., to honor women's military service.

IN THE WORDS OF "Dusty," a nurse in Vietnam

"When you are sitting there working on someone in the middle of the night, and it's a 19-year-old kid who's 10,000 miles from home, and you know that he's going to die before dawn . . . and you're the only one he's got— I mean his life is just oozing away there—well, it oozes into your soul. . . . that act of helping someone die is more intimate than sex, it is more intimate than childbirth, and once you have done that you can never be ordinary again."

III. Around Town

I t is untitled, undated, and unattributed. Still, this haunting and reflective memorial in Rock Creek Cemetery draws both tourists and residents who come to sit and contemplate. The hooded bronze figure seated against a block of pink granite is nestled in a grove of holly with a circular bench close

attracted a literary crowd, including the young **EDITH WHARTON** (1862-1937).

Marian's father, to whom she was extremely close, frequently visited her in Washington, and the two spent most summers together while Henry wrote. In spring 1885, when her father's health deteriorated, she

THE ADAMS MEMORIAL

by. It was installed in 1891 in a setting that was designed by architect Stanford White.

The memorial, often referred to as "Grief" or "The Peace of God That Passeth Understanding," honors **MARIAN HOOPER ADAMS** (1843-85), who took her own life at the age of 42, an apparent victim of depression.

Marian Adams, or Clover as she was fondly known, was a popular 19th-century hostess, first in Boston and later in Washington, and an amateur photographer. The wife of author Henry Adams, grandson and great-grandson of presidents, Marian was admired for her intellect and charm. Her parties and afternoon teas at her Lafayette Square home

traveled to New England to care for him during the last months of his life. After his death, Marian returned to Washington and soon thereafter sank into a depression. On December 6, 1885, she swallowed potassium cyanide, a chemical from her darkroom, and died.

Henry Adams, devastated by his wife's death, commissioned sculptor Augustus Saint-Gaudens to create the

Location: Rock Creek Church Rd. and Webster St., NW
Metro: Fort Totten
Phone: 202/829-0585
Hours: 24 hours a day, 7 days a week

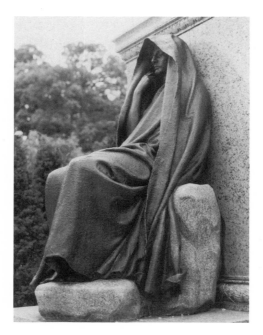

Marian Adams memorial

memorial, considered one of the sculptor's masterpieces. Its theme and style seem partly inspired by Adams's trip after his wife's death to Japan, where he became intrigued by Kwannon, a goddess of contemplation and compassion.

Years later, in a letter to Saint-Gaudens, Adams quoted with apparent approval a description of the sculpture by his friend, writer John Hay: "It is full of poetry and suggestion, infinite wisdom, a past without beginning, and a future without end, a repose after limitless experience, a peace to which nothing matters—all are embodied in this austere and beautiful face and form."

When he died in 1918, Henry Adams was buried in the grove near his wife.

Also in This Location

Elsewhere in Rock Creek Cemetery are the graves of these women:

• **PATRICIA ROBERTS HARRIS** (1924-85), the first black woman named a U.S. ambassador, also became the first black woman appointed to a president's cabinet

when President Carter named her Secretary of Housing and Urban Development in 1976. She was also dean of the Howard University Law School and an early civil rights activist in the city. Her grave is in Section 20-44.

• **ALICE ROOSEVELT LONGWORTH** (1884-1980), daughter of President Theodore Roosevelt and wife of Rep. Nicholas Longworth (later speaker of the House), was often called "Washington's other monument." When her father was president and she was living in the White House as a teenager, Alice became notorious for smoking in public, wearing slacks, driving a car without a chaperone, and betting at the races. As an adult, she was said to have prominently displayed a pillow that said, "If you can't say something good about someone, sit right here by me." One of the capital's most colorful and influential women for nearly a century, Longworth was a major social and political force until the final years of her life. Her grave is in Section F-51.

See also: on Harris, p. 41; on Longworth, pp. 96, 113.

The American Red Cross has provided humanitarian and emergency services to those in need since **CLARA BARTON** established it in 1881. Visitors to the organization's headquarters will find exhibits that tell the story of the Red Cross and its many services through objects, images, videos, and voices.

Posters in the galleries trace the story of how the Red Cross prepares for and responds to disasters. This story begins with Clara Barton responding to the Johnstown flood of 1889 and continues on to recent disasters such as the Oklahoma City bombing. The parallel story of nurses—who have always been an

AMERICAN RED CROSS HISTORY AND EDUCATION CENTER

The building itself was dedicated, in 1928, to the women who served in World War I.

Inside the Visitors Center in the E St. building, a touch-screen program, "The Red Cross Registry: Our Treasures, Our People," offers biographical information and images of women and men who have served with the American Red Cross.

> ✓ **Location:**
> 17th and E Sts., NW
> **Metro:** Farragut West
> **Phone:** 202/639-3300
> **Hours:** 9 am-4 pm, Mon.-Fri.
> **Web site:** www.redcross.org

important part of the Red Cross—is told in a display of pictures, uniforms, and clothing. Also included are the numbered pins worn by each nurse during her service and returned to the organization upon her death.

This section is also designed to demonstrate how the American Red Cross works with the International Federation of Red Cross and Red Crescent Societies in efforts crossing national borders. Examples of these efforts are the care of prisoners-of-war and victims of land mines.

In the Board of Governors hall in the 17th Street building, display cases hold items belonging to Clara Barton: her spectacles, a sewing kit she took on disaster missions, and

gifts people around the world presented to her in appreciation for the American Red Cross.

The Tiffany stained-glass windows in the hall tell a story of unity between women of the North and South following the Civil War. Of the three window panels, the one on the right representing the North was donated by the Women's Relief Corps of the North. The panel on the left, representing the South, was donated by the United Daughters of the Confederacy. Both panels tell stories of women and their good deeds. The two groups together created the center panel as a way of bridging differences after the war. This combined panel symbolizes ministry to the sick and wounded through sacrifice. Knights in armor are mounted on horses, and the standard bearer, an injured soldier near his horse's feet, carries a large flag with the Red Cross emblem. Visitors can view the windows when the hall is not being used for organization business.

On view on the second floor is the 1918 American Red Cross Quilt, made to raise money for expanding emergency services during World War I. The quilt was signed by five presidents, including Woodrow Wilson and Theodore Roosevelt, and such celebrities as **HELEN KELLER, MARY PICKFORD,** Ernest Hemingway, and Charlie Chaplin. Photographs of some of the signers are on the walls.

Red Cross Square is surrounded by gardens with memorials and statues. One of them honors **JANE DELANO**, founder of the American Red Cross Nursing Service.

See also: on Barton, pp. 11, 19, 129-31; on Keller, pp. 121, 122; on Delano, pp. 127-28.

IN THE WORDS OF Clara Barton (1898)

"It is wise statesmanship which suggests that in time of peace we must prepare for war, and it is no less a wise benevolence that makes preparation in the hour of peace for assuaging the ills that are sure to accompany war."

A frican-American educator and activist **MARY CHURCH TERRELL** (1863-1964) is known for saying, "Black women carry with them two heavy loads, the burden of race as well as sex." If Terrell perceived her loads as large, her accomplishments were also formidable. An ideal place the "gentlemen's course"—four years of classics. Proficient in several languages, she taught Latin at Washington's M Street School (a preparatory school for black students). Her fluency in French and German also enabled her to become one of the few black women reformers with international connections.

ANACOSTIA MUSEUM

to explore both is the Anacostia Museum, the only community-based museum within the Smithsonian Institution.

Nowhere do the issues of education, women's rights, and civil rights come together more powerfully than in Terrell's life. Born in Memphis, Tennessee, she was educated at Oberlin College where, unlike most female students, she took

✓ **Location:**
1901 Fort Place, SE
Metro: Anacostia; then, take W1 or W2 bus
Phone: 202/287-3369
Hours: 10 am-5 pm, daily
Amenities: educational programs, special exhibits

In 1895, Terrell became the first black woman to serve on the District of Columbia School Board, a position she held for the next 24 years. She founded the National Association of Colored Women and worked with Susan B. Anthony as a member of the National Women's Suffrage Association. She also led the picketing and sit-in at the all-white Thompson's Restaurant in 1950. This action led to a Supreme Court decision in 1953 that ended desegregation in Washington. Finally, at the age of 90, Terrell was served at the restaurant.

Some of Terrell's personal belongings are in the museum collection. Examples include the gown she wore at her graduation from Oberlin

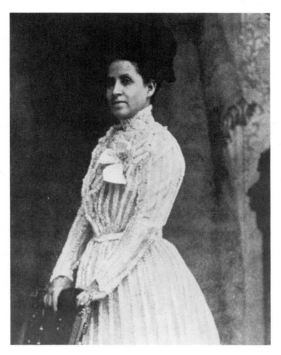

Mary Church Terrell

College and documents signed by Presidents Taft and Theodore Roosevelt appointing her husband, Robert H. Terrell, as Judge of the D.C. Municipal Court.

On display in the museum as well are items owned by Terrell's friend and colleague, **ANNA JULIA COOPER** (1859?-1964), also an African-American educator and activist. Cooper was born to a slave mother and her master in North Carolina, where she attended St. Augustine's Normal School. After graduation from Oberlin College in 1884, she taught at Oberlin and at Wilberforce University. For most of her remaining career, she taught and served as principal at the M Street School.

Her collection of essays, *A Voice from the South*, published in 1892, is considered the first book-length black feminist text. In 1925, at the age of 65, Cooper received a doctoral degree from the Sorbonne in Paris.

The permanent collection also includes the fur coat worn by **MARIAN ANDERSON** at her famous concert on Easter Day 1939 at the Lincoln Memorial. Anderson's concert scheduled for the DAR Constitution Hall had been cancelled because of her race.

Overall, the museum's mission is to explore African-American art, culture, and history through its exhibits and educational programs. Established in 1967 as a neighborhood museum, it moved into a new building in 1987 to better serve its redefined, national scope.

Aspects of women's history are often featured in rotating exhibits from the permanent collection, and special exhibits have focused on black women of achievement.

The museum's educational programs also regularly feature women's history. These include citywide bus tours of African-American women's history sites, historical reenactments, womanist theology forums, lectures, storytelling, films and videos, poetry readings, and arts and crafts activities, such as quilting workshops and dollmaking.

The museum was renovated in 1997 to include an archival center on the new mezzanine level. There, visitors—by appointment—can view documents and photographs in the collection.

See also: on Terrell, p. 11; on Anderson, pp. 36, 37, 107.

IN THE WORDS OF Mary Church Terrell (1896)

"We wish to set in motion influences that shall stop the ravages made by practices that sap our strength and preclude the possibility of advancement. . . . We proclaim to the world that the women of our race have become partners in the great firm of progress and reform."

W hen **MARY McLEOD BETHUNE** (1875-1955) was born in Maysville, South Carolina, the midwife who delivered her exclaimed, "She came with her eyes wide open. She'll see things before they happen." This statement would define Bethune's long and productive life.

from its founding in 1935 until 1949. During those years, she was a special advisor on black affairs to President Franklin Roosevelt, and she shared both a professional relationship and friendship with **ELEANOR ROOSEVELT.** As Director of the Division of Negro Affairs for the National Youth Administration, Bethune

MARY McLEOD BETHUNE COUNCIL HOUSE

The youngest of seventeen children of former slaves, this determined visionary picked cotton in the fields with her family until she received the opportunity to go to school. It was five miles to the schoolhouse and five miles home, but she always walked it, she said, "on winged feet." As an adult living in Daytona Beach, Florida, she started a school for black girls, which expanded under her guidance to include college level courses and eventually become Bethune-Cookman College.

Among the several organizations Bethune founded was the National Council of Negro Women (NCNW); she served as president

was responsible for increasing the number of scholarships to black youth, even during the Depression.

The "Council House," as it was known in Bethune's time, was the first Washington headquarters of the NCNW. From this three-story Victorian townhouse, Bethune spearheaded efforts to encourage black

 Location: 1318 Vermont Ave., NW
Metro: Farragut North or McPherson Square
Phone: 202/673-2402
Hours: 10 am-4 pm, Mon.-Sat.
Amenities: tours, lectures, children's programs, films

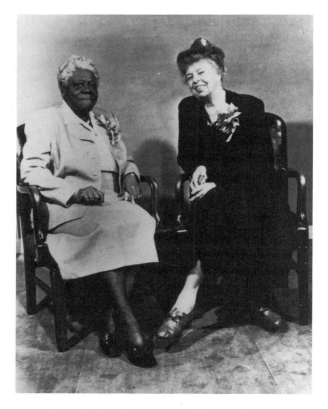

Mary McLeod Bethune and Eleanor Roosevelt

women's organizations to speak with one voice as a way to influence national politics and improve conditions for African-Americans. The house, now designated the Mary McLeod Bethune Council House, was declared a National Historic Site in 1982 and is maintained by the National Park Service.

On the first floor is a small exhibit about Bethune and the house,

along with some furniture from its early days. The visitor's center offers a video about Bethune's life.

On the second floor are Bethune's bedroom and office with photographs lining the walls and some original pieces of furniture. An interesting feature of this room is a facsimile of a note Eleanor Roosevelt wrote to her friend when Bethune urged President Roosevelt to appoint

an African-American to a high position in his administration. The first lady's forthright response explaining why that could not be done implies the strength of the friendship between the two women.

Also on the second floor is the NCNW meeting room, which contains the original conference table and exhibits on current and past presidents of the organization.

In the carriage house is the National Archives for Black Women's History, which grew out of Bethune's plan to create a research collection on African-American women. The archives include manuscripts, photographs, magazines, correspondence, personal papers, audiotapes, posters, and minutes of meetings of the NCNW and other black women's organizations.

A library upstairs contains historical and reference publications and databases, including one of photographic images. An appointment is required to use the archives.

The Bethune Memorial

Another tribute to Bethune can be found at Lincoln Park, located at 13th and East Capitol Streets, NE. Known as "Legacy" for the values she is passing on to the younger generation, the 12-foot-tall bronze statue is of a smiling, elderly Bethune with one hand on her cane and the other outstretched to two children.

Inscribed at the memorial's base are her words: "I leave you love. I leave you hope. I leave you the challenge of developing confidence in one another. I leave you a thirst for education. I leave you a respect for the use of power. I leave you faith. I leave you racial dignity. I leave you also a desire to live harmoniously with your fellow man. I leave you, finally, a responsibility to our young people."

Dedicated in 1974, the memorial was the first in a Washington public park memorializing a black woman.

See also: on Bethune, p. 37; on Roosevelt, pp. 35-37, 54, 56, 106, 112, 115, 138.

The National Society of the Daughters of the American Revolution (DAR) was founded in 1890 by a group of women who were descendants of patriots from the Revolutionary War. Members are women who share this ancestry. The organization fulfills its mission of perpetuating "the glimpse into the lives of mostly affluent white women during the late 18th and early 19th centuries. Furniture and other objects are organized into 33 rooms, each illustrating life in a different place and time.

Highlights include:

• The Washington, D.C., Room presents a parlor scene from the early

THE D.A.R. COMPLEX

memory and spirit of the men and women who achieved American Independence" though the museum, genealogy library, and activities at this stately complex covering an entire city block.

The museum in Memorial Continental Hall offers visitors a vivid

✓ **Location:**
1776 D St., NW
Metro: Farragut West
Phone: 202/879-3241
Hours: 8:30 am-4 pm, Mon.-Fri.; 1-5 pm, Sun. Closed for two weeks in April and on federal holidays.
Amenities: genealogy library, tours of the period rooms between 10 am and 2:30 pm

1800s. There is a tea set on the wooden tea table. On the wall are a portrait of George Washington and a landscape painting of the DAR property before it was developed into the museum site.

• The Maryland Room depicts another parlor setting, this one in the 1820s and featuring furniture crafted by a Baltimore carpenter. Next to the door is a Harmonican, a musical instrument made by a Baltimore resident. It consists of a box of glassware played the way a wine glass is played: by wetting one's finger and running it around the tops of the glasses. Other objects of interest include a painted side chair belonging to Francis Scott Key.

• The Tennessee Room has an 1820s White House theme, complete with three chairs owned by President Monroe. The pink parlor has a fireplace and a rose Aubusson carpet. On the wall is a Thomas Sully portrait of **FANNY KEMBLE,** an English actress who was popular in America as well. Kemble also wrote *Journal of a Residence on a Georgian Plantation in 1838-1839,* in which she expressed her antislavery opinions.

• The Indiana Room is a library from the 1830s. It includes a standup fire screen with an intricate needlepoint face and a desk with a wood perspective glass (magnifier). A book press stands near the opposite wall.

• The North Carolina Room is a lavish dining room from the 1830s. Silver serving pieces and utensils are arranged on the dining tables and two sideboards, and the table is set for a dessert course with creamware dishes inscribed with an armorial pattern. By the fireplace is a plate warmer.

• The Missouri Room shows a late Victorian parlor setting from the 1850s. Parlors, or sitting rooms, were the focal point for entertaining and family gatherings. This ornate, crowded room is decorated with elaborate detail, as seen in every piece of furniture and object in the room, down to the ceramics and the historically accurate wallpaper.

• The Oklahoma Room is a rustic, 19th-century kitchen, which was both the center of home life and the place where women in less wealthy families spent most of their time. Objects offer a glimpse of what these women's lives were like and the chores they performed. Included are a butter churner, spinning wheel, pots and pans, candle molds, water basin, sausage stuffer, pewter plates, and even a mouse guillotine.

Aside from the period rooms, the DAR library owns an extensive collection of genealogical materials. The museum displays such objects as a pair of garnet earings owned by **DOLLEY MADISON** and some clothing and letters of **MARGARET CHANDLER,** an early abolitionist. The collection includes a "settee-bed," an all-wood sofa that pulled out to form a canvas bed—an early 1800s version of the modern sofa-bed.

The museum also owns a collection of quilts, some of which are always on display in the gallery, along with their histories and information about the women who made them.

See also: on Madison, pp. 54, 56, 104, 110-11, 112-13, 114, 121.

A mong the varied historical objects and works of art in the National Jewish Museum are a number reflecting the role of women in Judaism.

One of the holiest of all Jewish customs, the family Sabbath ceremony on Friday evenings begins with a ritual of lighting and blessing because they come from a community destroyed in the Holocaust.

In addition to bringing in the Sabbath with candles, women read prayers, sometimes from cloths they stitched themselves. In the same exhibit is a 17th-century, cream-colored silk wall hanging embroidered with 27 lines of text and prayers that a

NATIONAL JEWISH MUSEUM

of candles in the home. Women traditionally light these candles. Among the candlesticks on display in the "Shabbat/Havdallah" exhibit are a large, ornamental silver pair from Danzig, Poland. These are significant because they date back to 1680 and

Location:
1640 Rhode Island Ave., NW
Metro: Farragut North
Phone: 202/857-6583
Hours: 10 am-5:30 pm, Sun.-Fri.
Amenities: education programs, docent tours by appointment, museum shop, temporary exhibits

woman recited as she kindled the Sabbath lights. Part of the prayer is: "May my children be wise and learned lovers of the Lord so that they might enlighten the world with their knowledge and good deeds."

Jewish women are also responsible, though not exclusively, for creating ceremonial needlework pieces, such as Torah binders. Traditionally, a woman created a Torah binder for her husband by using the swaddling cloth from his circumcision. Inscriptions on the binders include wishes for a long, happy life. The oldest Torah binder on display was made in 1556 by **FIRNA FINZI**, a member of the wealthiest and most highly regarded Jewish family in Italy until the Holocaust. Finzi's Torah binder

is on view in the "Synagogue" exhibit; other Torah binders rich with needlework may be found in the "Lifecycles" exhibit.

Marriage certificates (*ketubot*) are an especially revealing part of Jewish women's history because, even in ancient times, they characterized the bride as a human being and a person in her own right, rather than a possession passed along from her father or brothers to her husband.

Marriage certificates, some of them colorful, in the "Daily Life" exhibit were inscribed in Aramaic on parchment paper. These certificates dating back to the 1600s state the conditions of marriage to which both the bride and groom agreed. During the wedding ceremony, marriage certificates were read aloud for all to bear witness to the agreed-upon conditions for matrimony. This ritual has survived to present times.

In the same display case is a Halitza shoe, a leather overshoe used in a Halitza ceremony. Beginning in Biblical times, if a Jewish woman's husband died, his brother was expected to marry the widow, and their first child was named after the deceased brother. If the two did not wish to carry out this tradition, they held a Halitza, a formal ceremony to relieve them of their obligation. The ritual included spitting on the shoe.

In addition to ceremonial items, the museum contains works of art by women—some inspired by their faith and by their perspectives as Jewish women.

A sculpture by **ISABEL KAHN** titled *Self Container* (1994), for example, reflects on the times in her youth when she watched her father put on phylacteries, a ritual in which men attach ceremonial boxes to their foreheads and arms before reciting morning prayers. With the sculpture—which consists of three stacked boxes, each adorned with images of women and feminine items such as lace—Kahn is wondering about her place in a tradition that excludes women from many of its rituals.

The National Jewish Museum is located on the first floor of the headquarters of B'nai B'rith, the oldest Jewish social service organization in the world. The museum also houses the Jewish American Sports Hall of Fame, which honors Jewish athletes, and a collection of Jewish ceremonial and folk art.

T he National Museum of American Art is home to a invaluable record of the nation's history and concerns as seen by its artists. The collection of more than 35,000 paintings, sculptures, photographs, and folk art is thus as diverse in culture, subject matter, and style as is America itself.

were donated to the Smithsonian Institution in 1862.

The growing collection was housed and displayed in various buildings of the Smithsonian over the years, for the longest time in the Museum of Natural History. In 1968, it was installed in its own building, then given its own name in 1980 to reflect

NATIONAL MUSEUM OF AMERICAN ART

The museum's beginnings go back to the collection of Washingtonian John Varden in 1829, which was combined with the holdings of the congressionally mandated National Institute in 1841. All of these works

✓ **Location:** 8th and G Sts., NW
Metro: Gallery Place/ Chinatown
Phone: 202/357-2700; TTY 202/357-1729
Hours: 10 am-5:30 pm, daily. Closed Christmas Day.
Amenities: gift shop, cafeteria
Web site: www.nmaa.si.edu

the mandate to show exclusively the works of American artists. A number of women artists are represented in the collection.

One of the first American women artists to create politically oriented work was **EDMONIA LEWIS** (1843?-1911?), daughter of a freed black father and a Chippewa mother. Orphaned at the age of three and raised by her mother's tribe, Lewis became a gifted sculptor whose work was directly influenced by her heritage and life experiences, including the time she was beaten by a group of vigilantes while attending Oberlin College. As an adult she lived primarily in Italy.

Edmonia Lewis's
Death of Cleopatra

Lewis is best known for her portraits of abolitionists and her marble historical sculptures, including the *Death of Cleopatra* (c. 1875). This piece was discovered in a Chicago junkyard in the mid-1970s and identified by the Historical Society of Forest Park, Illinois. In 1994, the society gave it to the museum, where it was finally restored.

Another of Lewis's memorable sculptures is of Hagar, a maidservant in the Old Testament who was cast into the wilderness by her jealous master. *Hagar* (1875) became for

many a symbol of all women who have struggled or suffered.

Some of the early trailblazers for women in the arts were portraitists like **LILLY MARTIN SPENCER** (1822-1902), who became known as one of the best genre painters of her time. Like most women artists of her time, Spencer lacked any formal training. However, she developed considerable skill that elevated her to the level of her male contemporaries. She went on to create a large number of paintings to meet consumer demands and even supported

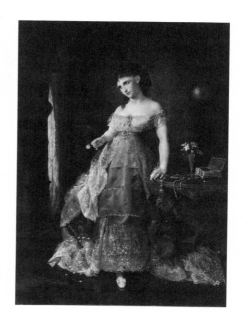

We Both Must Fade
by Lilly Martin Spencer

her husband and seven children on fees she collected. Her *We Both Must Fade* (1869) is a somewhat sentimental depiction of a young woman wearing an ice blue dress with elaborate lace trim and holding a rose.

CECILIA BEAUX (1855-1942), another portraitist, was considered even more daring than Spencer, for Beaux rejected marriage to concentrate on her career. The collection contains four of her works, including *Man with the Cat* (1898), an example of her trademark style using shades of white paint and fluid brush strokes.

The museum also owns works by more contemporary female artists. **MIRIAM SCHAPIRO** (1923-), an abstract expressionist inspired by the feminist movement, is represented by five of her most recent works. Schapiro is the creator of "femmage" in art: using women's domestic objects in collages to tell a story. She is also notable for mentoring **JUDY CHICAGO,** whose best-known work, *The Dinner Party,* was made up of elaborate life-size place settings honoring notable women in history.

The massive *Sky Cathedral* (1982) by **LOUISE NEVELSON** is

a large-scale collection of found objects, compartmentalized and covered in black paint. The sculpture was commissioned by the American Medical Association, which displayed the work in the lobby of its national headquarters in Washington until 1994 when the building was renovated. At that point, the sculpture was donated to the museum.

Other painters—**ROMAINE BROOKS, JOAN MITCHELL, HELEN FRANKENTHALER**, and **LEE KRASNER**—are also represented in the museum, as well as sculptors **LOUISE BOURGEOIS, ANNE TRUITT,** and **ELIZABETH CATLETT.**

Finally, the collection includes the work of several female artists who lived in Washington, D.C. **VINNIE REAM**'s marble statue of **SAPPHO** is owned by the museum, as is a portrait of Ream by George Peter Alexander Healy.

ALICE PIKE BARNEY (1859-1931) was known not only for her art but for creating an arts community in the capital. A wealthy Bohemian from Ohio, Barney moved to Washington in 1889 with her wealthy husband and two daughters. She painted every day, despite her social and family obligations and her husband's disapproval. A skilled and prolific portraitist, Barney once studied with James McNeil Whistler.

In her role as a cultural activist, Barney opened Studio House on Massachusetts Ave., NW, where she hosted plays, poetry readings, art exhibitions, and other arts programs. She was also the driving force behind the creation of the Sylvan Theater on the grounds of the Washington Monument, and she wrote and produced its first plays.

Self Portrait *(1923)*
by Romaine Brooks

The museum has nearly 300 of Barney's paintings, including a portrait of Washingtonian **ALICE ROOSEVELT LONGWORTH.**

A long-time art teacher in Washington's schools, **ALMA THOMAS** (1891-1978) was an abstract expressionist who became widely recognized in her later years and was the first black woman to have a solo exhibition at New York's Whitney Museum. Two of her colorful paintings are in the collection.

Due to space constraints, the collection is exhibited on a rotating basis. Check at the information desk for availability and location of individual works.

See also: on Spencer, p. 99; on Mitchell, p. 49; on Nevelson, 39, 49, 101; on Mitchell, p. 49; on Frankenthaler, pp. 48-49, 101; on Krasner, pp. 49, 101; on Bourgeois, pp. 39, 48; on Ream, 22-23, 126; on Sappho, pp. 13, 126; on Longworth, pp. 79, 113; on Thomas, pp. 48, 101.

● *on this spot:* MCI CENTER ●

When **SUSAN O'MALLEY** was in elementary school, she wrote a paper saying that her goal in life was to run a sports franchise. Her teacher called that dream unrealistic, but today O'Malley is one of the most powerful women in professional sports. As president of Washington Sports and Entertainment, O'Malley not only oversees all business operations for the Washington Wizards basketball team and the Washington Capitals hockey team, but in 1997 she headed the successful marketing efforts for MCI Center, an innovative sports facility and entertainment complex at F and 7th Streets, NW.

A popular speaker at events across the country, O'Malley is known as a master motivator of staff, a creative developer of marketing and communications strategies, and a strong supporter of community service projects. Most recently, she played a key role in acquiring an expansion team for Washington in the Women's National Basketball Association (WNBA). The new Mystics will begin playing in June 1998. For ticket information, call 301-NBA-DUNK.

The National Museum of Women in the Arts is the only museum in the world dedicated solely to works of art by women. Displayed on four floors, the collection includes art from the Renaissance to the present. As a whole, the works represent a compelling array of images. Separately, they reflect

Initially, the Holladays offered docent tours of their home. Then, in 1987, the museum—established, in their words, "to encourage greater awareness of women in the arts and their contributions to the history of art"—opened to the public in a renovated Renaissance-style building. Since then, the collection has grown

NATIONAL MUSEUM OF WOMEN IN THE ARTS

the individual expressions, struggles, and achievements of a wide range of women artists.

The story behind the museum's founding is itself notable. In the 1960s, Washington philanthropists **WILHELMINA COLE HOLLA-DAY** and her husband, Wallace F. Holladay, recognized that women were underrepre-sented in the art world and began collecting significant works by women to start a museum. Over the next two decades, the couple collected more than 300 works by female artists, including many from the 17th and 18th centuries which became the seed collection.

to more than 2,500 works by more than 500 artists from 28 countries. Although only a portion of the collection is on display at any one time, visitors can almost always view the museum's most prized works.

 Location: 1250 New York Ave., NW
Metro: Metro Center
Phone: 202/783-5000
Hours: 10 am-5 pm, Mon.-Sat.; noon-5 pm, Sun.
Amenities: special exhibitions, education programs, library and research center, Mezzanine Cafe, gift shop
Web site: www.nmwa.org

On the third floor, where tours begin, the works are hung in chronological sequence. At the entrance are works by Renaissance artists. *Portrait of a Noblewoman* (1580) by **LAVINIA FONTANA** (1552-1614) is a splendid and intricate painting in regal gold and maroon. Fontana supported her husband and 11 children with her work. Her *Holy Family with Saint John* (n.d.) was painted at a time when not only were women artists rare, but women painting historical or religious scenes were virtually nonexistent.

Another successful early artist who dared to paint religious themes was **ELISABETTA SIRANI** (1638-65). On display are her *Virgin and Child* (1663) and *The Holy Family with Saint Elizabeth and Saint John the Baptist* (n.d.).

In the Dutch and Flemish section, **JUDITH LEYSTER** (1609-60), who started her career in her teens, is represented by *The Concert* (c. 1631-33). Also on view is *Still Life of Fish and Cat* (undated) by **CLARA PEETERS** (1594-1657). Peeters is important not only for her art but for her role, if unwitting, in the museum's origins: She is the artist who first inspired the Holladays to collect women artists' works.

The *Metamorphosis* series of botanical engravings is by **MARIA SIBYLIA MERIAN** (1647-1717), the first artist to document the life cycle of an insect in one scene. In 1997, two of her exhibited works appeared on U.S. postage stamps.

Among eighteenth-century artists is **ELISABETH VIGÉE-LEBRUN** (1755-1842), a court painter to Marie Antoinette and members of French society. Included are her *Portrait of Princess Belozersky* (1798) and *Portrait of a Young Boy* (1817).

ANGELICA KAUFFMANN (1741-1807), also from that period, is best known for her historical scenes and symbolism. At an early age, Kauffmann gained access to the works of the masters and learned to paint by copying them. On display are her *Cumaean Sibyl* (c. 1763) and *The Family of the Earl of Gower* (1772).

Although still severely underrepresented in the art world, 19th-century women artists began to be accepted into art schools where for the first time they received formal training. Notable artists of that time represented in the collection are Impressionist painters **MARY CASSATT** (1844-1926) and

Young Girl
with a Sheaf
by Camille Claudel

BERTHE MORISOT (1841-95), each of whom became the first female student at an elite art school.

ROSA BONHEUR (1822-99) was acclaimed as an animal painter at a time when most women painted exclusively women and children. On display is her *Sheep by the Sea* (1869). Also on view is the small bronze sculpture *Young Girl with a Sheaf* (1890) by French artist **CAMILLE CLAUDEL** (1864-1943).

Turn-of-the-century American artist **LILLA CABOT PERRY**
(1848-1933), known for her portraiture, is represented by *Lady with a Bowl of Violets* (1910), *Lady in an Evening Dress* (1911), and *Portrait of Elsa Tudor* (1898).

LILLY MARTIN SPENCER (1822-1902), another American, is known for her genre scenes and portraits. On the surface, Spencer's epic *The Artist and Her Family at a Fourth of July Picnic* (1864) appears to be a family enjoying the patriotic holiday. From the historical perspective, however, it explores race relations at the time of the Civil War.

Frida Kahlo's Self Portrait Dedicated to Leon Trotsky

The early 20th century was an exciting time for woman artists as they were finally becoming able to present their work in their own right and receive recognition for it.

Their subject matter broadened as well, and they began painting nudes and other formerly taboo subjects. **SUZANNE VALADON** (1865-1938), for example, presented pubescent young girls in *The Abandoned Doll* (1921) and *Nude Doing Her Hair* (1916).

Mexican painter **FRIDA KAHLO** (1907-54), on the other hand, often revealed her own physical and mental pain in her vivid and sometimes horrifying self-portraits. Kahlo also dared to present her political beliefs in her art. In the well-known *Self Portrait Dedicated to Leon Trotsky* (1937), she portrays herself in a Mexican peasant outfit, holding a note to Trotsky as a way of pledging her allegiance to Marxism and the Mexican Revolution.

KÄTHE KOLLWITZ (1867-1945), whose etchings and sculptures portray the plight of poverty and her abhorrence of war, was one of the most influential German printmakers of the early 20th century. Her sculptures *Rest in His Hands* (1936) and *The Farewell* (1940) and etchings *A Weaver's Rebellion* (1920), *The Downtrodden* (1900), and *Self-Portrait* (1921) are in the collection.

Contemporary works appear on the second and third floors and the mezzanine level. These include:

• paintings by abstract expressionist **HELEN FRANKEN-THALER** (1928-);

• the totemic, wood sculpture of **LOUISE NEVELSON** (1900-88), including *White Column* (1959), one of 12 pieces of "Dawn's Wedding Feast";

• *Iris, Tulips, Jonquils, and Crocuses* (1969) and *Orion* (1973) by **ALMA THOMAS** (1891-1978), a Washingtonian who created brightly colored abstract renditions of nature;

• *Superwoman* (1973) by **KIKI KOGELNIK** (1935-), which shows a capped woman in a confident, challenging posture, holding a large pair of scissors; and

• *The Springs* (1964), a landscape of earthy colors, a metaphor for life itself, by **LEE KRASNER** (1908-84).

The collection also includes Native American pottery and photography. **BERENICE ABBOTT** (1898-1991) captured 20th-century life on the Left Bank of Paris in her pictures. Another photographer, **LOUISE DAHL-WOLFE** (1895-1989), used her reputation as a prominent fashion photographer to promote a carefree, girl-next-door style.

In addition to the permanent collection, the museum offers temporary exhibits like "From the States," which features each month an artist from a different state. This exhibit was launched in 1997 to mark the museum's tenth anniversary.

IN THE WORDS OF Berenice Abbott

"Some people are still unaware that reality contains unparalleled beauties. The fantastic and unexpected, the ever-changing and renewing is nowhere so exemplified as in real life itself."

The Great Hall of the National Museum of Women in the Arts, viewed from the mezzanine.

The museum also hosts "forefront," which presents the art of emerging female artists, a series of exhibitions called "Book as Art," and a lecture series with women writers. In addition, through 17 state chapters, NMWA supports exhibits, programs, and lecture series throughout the nation.

As a private institution, the museum has from the beginning welcomed members from around the country and the world, whose annual donations at various levels support its activities. Members receive a quarterly four-color newsletter, invitations to opening night receptions, gift shop discounts, early notification of museum events, and, most of all, the satisfaction that they are contributing to the support of women artists and their works. For more information, contact the museum's membership office.

See also: on Leyster, p. 46; on Vigée-Lebrun, pp. 46-47; on Kauffman, pp. 46, 47; on Cassatt, pp. 38, 47, 105; on Morisot, p. 47; on Spencer, pp. 93-94; on Kollwitz, p. 48; on Frankenthaler, pp. 48-49, 95; on Nevelson, pp. 39, 49, 94-95; on Thomas, pp. 48, 96; on Krasner, pp. 49, 95

Although readers may be familiar with the names and accomplishments of notable women in American history, including those in this book, how can they satisfy that burning question: "But what did she look like?" The answer for many may be found with a visit to the National Portrait Gallery, where portraits of famous Americans from the 1600s to the present are on display. Those mentioned here are only a sample of the women featured in the museum.

Also in the room is a portrait of **ANNE GREEN** (1720?-75), who successfully took over her husband's Annapolis, Maryland, printing press after his death. Colonial printers not only provided the sole means of communication among residents, but served the roles of public officials and archivists. Because women

NATIONAL PORTRAIT GALLERY

For a historical perspective, visitors should begin on the second floor in the "Galleries of Notable Americans." In Colonial America (room 204) is a portrait of **POCAHONTAS** (c. 1595-1617), wearing colorful European clothing instead of her traditional American Indian attire. The daughter of a Powhatan chief, Pocahontas made friends with the early American settlers. After marrying settler John Rolfe, she made a celebrated trip to England. This portrait was painted from her only known life portrait, an engraving made in England in 1616.

often took over presses after the death of their husbands or fathers, the printing profession was one of the few influential trades that women participated in during this period.

In the Age of Revolution (room 206) is a portrait of **PATIENCE LOVELL WRIGHT** (1725-86), who turned her hobby of sculpture

 Location:
8th and F St., NW
Metro: Gallery Place/
Chinatown
Phone: 202/357-2700
Hours: 10 am-5:30 pm,
daily. Closed Christmas Day.
Amenities: gift shop, public
events, temporary exhibits,
guided tours, cafe
Web site: www.npg.si.edu

into a profession after her husband's death. Wright's portrait shows her at work molding a wax head in her lap underneath her apron. Wright worked secretly this way while entertaining guests. She is known as America's first native-born sculptor.

As the new republic began to take shape (room 210), some women are honored for their roles in its development. **DOLLEY MADISON,** in a portrait of the Grand Dame of Washington society, is depicted in the last years of her life, wearing her trademark turban. Also in this room is a portrait of **LUCRETIA MOTT** (1793-1880), a Quaker minister, suffragist, and abolitionist.

In the hallway are images of women who contributed to the development of American cultural life. They include actress **CHARLOTTE CUSHMAN** (1816-76), who was known for her bold, masculine style of dress; and **LOUISA MAY ALCOTT** (1832-88), author of many books, including the classic *Little Women.* Around the corner is a painting of **JULIA MARLOWE** (1866-1950), a popular stage actress acclaimed for her performances in Shakespearean plays.

The turn of the 20th century (rooms 211-213 and hallway) was a dynamic time for American women and their efforts to bring about change. Some heralded for their contributions include the following.

JANE ADDAMS was a social reformer and peace activist best known for founding Hull House in Chicago, a settlement house to help improve social conditions for the poor. **SUSAN B. ANTHONY,** a key leader of the woman's suffrage movement, is depicted in a bronze bust sculpted by suffragist artist **ADELAIDE JOHNSON.**

Another suffrage leader, **ELIZABETH CADY STANTON,** is portrayed in her later years. Stanton was the prime mover behind

IN THE WORDS OF Louisa May Alcott, in *Little Women*

"Don't shut yourself up in a bandbox because you are a woman, but understand what is going on, and educate yourself to take part in the world's work for it all affects you and yours."

the 1848 Seneca Falls Convention, which sparked the women's rights movement. She sat for the portrait by **ANNA E. KLUMPKE** while visiting her son in Paris.

BELVA ANN LOCKWOOD, an attorney and another leader of the women's rights movement, ran for president even before women had the right to vote in national elections. She is depicted in the commencement robes she wore when receiving an honorary doctorate from her alma mater, Syracuse University, in 1908.

In the next room, **CARRIE CHAPMAN CATT** (1859-1947), a suffrage leader who also founded the League of Women Voters after the ratification of the 19th Amendment, is portrayed in her later years, sitting comfortably with a book. Also featured are **JULIETTE LOW** (1860-1927), founder of the Girl Scouts of America, and **LILLIAN WALD** (1867-1940), a social reformer who established the Nurse's Settlement House in New York.

American women are honored, as well, for their contributions to art and literature (second floor hallway, rooms 214 and 219). Impressionist painter **MARY CASSATT** was painted by her friend, Edgar Degas. Cassatt, however, was so unhappy with the serious look on her face and her hunched posture that she refused to sell the painting to an American collection, fearing that friends or family might see it.

The large terra-cotta sculpture of Modernist poet and arts patron **GERTRUDE STEIN** (1874-1946) depicts her in a seated position as a modern-day Buddha.

Other women represented include poet **EDNA ST. VINCENT MILLAY** (1892-1950), who wrote "On Thought in Harness" while sitting for this portrait; **MARTHA GRAHAM** (1894-1991), pioneer of modern dance, shown clad in a brown leotard as she appeared in "Tragic Holiday"; **GERTRUDE VANDERBILT WHITNEY** (1875-1942), creator of several of Washington's outdoor sculptors and founder of the Whitney Museum in New York; and playwright and memoirist **LILLIAN HELLMAN** (1905-84), whose statement that she "would not cut [her] conscience to fit this year's fashion" summed up her courage when testifying to the House Un-American Activities Committee during the communist witch hunts of the 1950s.

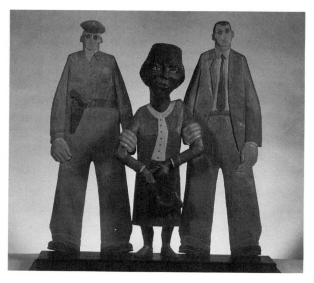

Sculpture of Rosa Parks being arrested

Still other women are honored for their courageous efforts to enhance the social and political fabric of the nation (rooms 216-219 and alcove). In one of the great moments in U.S. history, **ROSA PARKS** (1913-), an African-American seamstress returning home from work in Montgomery, Alabama, late one night in 1955, refused to yield her bus seat to whites. Her action helped launch the bus boycott in that city and became a symbol of the small, daily injustices of segregation that the civil rights movement sought to overcome. Parks is depicted in a wood carving, wearing a red, white, and blue suit, her hands cuffed and police officers at her side.

Other women represented in these rooms include **MARGARET SANGER**, who dedicated her life to helping women gain access to birth control; biologist **RACHEL CARSON** (1907-64), whose book *The Silent Spring* awakened the country to the dangers of environmental damage; **FRANCES PERKINS**, an advocate for labor reform and America's first woman cabinet member; **AMELIA EARHART**, pioneer of flight; **CLARE BOOTH LUCE** (1903-87), a member of Congress, ambassador, and editor; and **ELEANOR ROOSEVELT**, who as first lady and afterwards dedicated herself to social and political reform.

On the museum's first floor are sports and entertainment honorees. On display is a large, three-dimensional metallic portrait of Broadway diva **ETHEL MERMAN** (1909-84), dressed as Annie Oakley in the musical *Annie Get Your Gun*.

Also included are portraits of singers **MARIAN ANDERSON** and **LEONTYNE PRICE** (1927-), both of whom overcame racism to become international stars; actress **TALLULAH BANKHEAD** (1902-68), wearing a peach negligee, pearls, and bright red lipstick; and **ALTHEA GIBSON** (1927-), an African-American tennis star who won 17 titles, including Wimbledon, and is shown in a photograph surrounded by admiring children.

The third floor mezzanine, which is devoted to the Civil War, includes portraits of **JULIA WARD HOWE**, who wrote the "Battle Hymn of the Republic," and **HARRIET BEECHER STOWE** (1811-96), author of the antislavery novel *Uncle Tom's Cabin*. This book had such a powerful impact on its readers that President Lincoln is said to have remarked on meeting Stowe, "So this is the little lady who started this great war?"

Also in this area is a small photograph of **SOJOURNER TRUTH**, a former slave who spent her life speaking out on the issues of antislavery, woman suffrage, and temperance. She sold pictures of herself, such as the one on display, to help fund her speaking engagements. Printed on the card are the words "I sell the shadow [photograph] to support the substance." Despite her inability to read and write, Truth was a compelling orator and brilliant strategist whose contributions to the movements seeking rights for women and African-Americans were key to their success. She lived in Washington from 1860 to 1870.

See also: on Pocahontas, pp. 23-24; on Madison, pp. 54, 56, 89, 110-11, 112-13, 114, 121; on Mott, pp. 8, 17, 21; on Alcott, p. 122; on Addams, p. 60; on Anthony, pp. 8, 12, 17, 19, 21, 59, 82, 122; on Johnson, pp. 8, 17, 21; on Stanton, pp. 8, 17, 19, 21, 59, 122; on Lockwood, pp. 7-8, 31; on Catt, p. 11; on Cassatt, pp. 38, 47, 98; on Whitney, p. 117; on Sanger, pp. 12, 62; on Perkins, pp. 40-41; on Earhart, pp. 12, 42-43; on Luce, p. 12; on Roosevelt, pp. 35-37, 54, 56, 85-86, 112, 115, 138; on Anderson, pp. 36, 37, 84; on Howe, p. 116; on Stowe, pp. 59, 122; on Truth, pp. 19, 122.

Now a historic house museum, Tudor Place is the mansion built for **MARTHA CUSTIS PETER** (1777-1854), granddaughter of Martha Washington, on land Peter purchased with her inheritance. The architect, Dr. William Thornton, also designed the U.S. Capitol. The century, especially during the Civil War years when government officials might have claimed the house as public property.

Martha Custis Peter and her husband, Thomas Peter, raised five children in the house and entertained some of the world's most prominent people, including the Marquis de

TUDOR PLACE

house, which was completed in 1816, is filled with furniture and objects representing six generations of the Custis family.

According to curator Leni Preston, the mansion would not have remained in the family for more than 177 years without the strength of the women who lived in, preserved, and protected the house in the 19th

Lafayette. Martha had strong political beliefs and expressed them freely. She even gave her daughters political names, such as America Pinckney and Britannia Wellington.

After her mother's death, **BRITANNIA WELLINGTON** (1815-1911) inherited the house and is credited with keeping it intact even though she had to open it for use by soldiers during the Civil War.

Britannia was also a founding member of the National Society of the Colonial Dames of America, which held its first meeting at Tudor Place. After Britannia's death in 1911, the home was left to the Peter grandchildren. They divided the contents, but later Armistead Peter Jr.

> ✓ **Location:**
> 1644 31st St., NW,
> in Georgetown
> **Phone:** 202/965-0400
> **Hours:** Tours at 10 am,
> 11:30 am, 1 pm, 2:30 pm,
> Tues.-Fri., and on the hour
> from 10 am to 3 pm, Sat.
> *Entrance fee*

bought out his siblings' share. The house was bequeathed to his son, who turned it over to a foundation established to preserve the house and operate it as a museum.

The museum contains an extensive archive from the mid-18th century to the 1980s, as well as a significant collection of Mt. Vernon heirlooms, furniture, and objects. One of the newest acquisitions is a locket holding locks of both George and Martha Washington's hair.

The collection also contains a needlepoint seat cover stitched by Martha Washington after the death of her husband, a braided bracelet made from Martha Peter's hair, and a Revolutionary War camp stool used by George Washington.

The 5 1/2-acre landscaped garden was planted by the 19th-century women who lived there.

In the fall of 1997, Tudor Place began offering regular tours of the house under the title "Women of the 19th Century." These tours focus on the lives of Martha Peter and her daughters.

See also: on M. Washington, pp. 54, 68, 113, 121, 122, 132-34.

Granted, first ladies achieve their status through marriage to the country's highest elected official. And granted, their traditional role is that of chief national hostess during their husband's term in office. Yet, far more than their social accomplishments, it is the issues to which first ladies have called

Consider **DOLLEY MADISON** (1768-1849), wife of President James Madison. During the War of 1812, when the British set fire to the White House, she was instrumental in saving a treasured portrait of George Washington and other important objects. Although she did not literally run from the flames clutching

THE WHITE HOUSE

attention and their contributions to defining and preserving American life and heritage for which they are best remembered.

 Location: 1600 Pennsylvania Ave., NW; Visitors Center: 1450 Pennsylvania Ave., NW
Metro: McPherson Square
Phone: 202/456-2000, 202/456-7041; Visitors Center: 202/208-1631
Hours: 10 am-noon, Tues.-Sat.; Visitors Center: 7:30 am-4 pm, daily
Amenities: book shop at the Visitors Center and a small counter inside the White House; see end of entry for tour information

the likeness of the father of our country in her hands, her efforts in directing the portrait's removal were key to preserving that cherished piece of our national heritage. The Washington portrait is the only object from that period displayed in the present-day White House.

Madison was an influential woman in many other ways. She was the nation's top hostess in three periods: during the presidential terms of the widowed President Thomas Jefferson; as first lady in her husband's time in office from 1809 to 1817; and during the last 13 years of her life, when she returned to Washington after her husband's death and entertained in her home on

Dolley Madison

Lafayette Square (1521 H Street, NW). As first lady, her warm and vivacious personality eased partisanship in her husband's administration, even while she shocked many by opening the White House to all women for her Wednesday socials.

Another famously influential first lady was **EDITH WILSON** (1872-1961), who was a widow running a Washington jewelry store when she became the second wife of Woodrow Wilson in 1915. Wilson had a keen interest in domestic and foreign policy and was a constant companion to her husband. When the president, on October 2, 1919, had a stroke that left him incapacitated, she became his sole link with his staff. At the time, the president was seeking Senate approval for U.S. membership in the League of Nations. Edith Wilson hotly denied rumors that she was making decisions during this time, but she was instrumental in serving as a conduit between him and the rest of the government.

President Wilson died three years after leaving office in 1921, but Edith lived in their house at 2340 S St., NW for nearly 40 more years. Today, the house with its original furnishings and portraits is a museum, open from 10 am to 4 pm, Tues.-Sun.

In addition to the behind-the-scenes policy involvement of Madison and Wilson, many first ladies—especially in the 20th century—have used their position to draw attention to their favorite causes.

ELEANOR ROOSEVELT, in particular, is credited with expanding the first lady's duties by taking an active role in affairs ranging from civil rights to world peace. Among her many efforts on behalf of women's rights, Roosevelt held Saturday afternoon teas at the White House for working women from various federal agencies, choosing that day to listen to their concerns in recognition of their professional obligations during the week.

LADY BIRD JOHNSON (1912-) pushed for environmental efforts, including programs to "beautify" the nation's rural and urban areas. **BETTY FORD** (1918-) supported passage of the Equal Rights Amendment while her husband was in office and, afterward, called important attention to the problems of alcoholism and breast cancer. **ROSALYNN CARTER** (1927-) advocated improved conditions in mental health care.

NANCY REAGAN (1923-) spoke out on the issue of drug use by young people, and **BARBARA BUSH** (1925-) promoted literacy. **HILLARY RODHAM CLINTON** (1947-), the first first lady with an office in the West Wing, has been a strong voice in issues involving children and health care.

The Residence Itself

Over the years, the White House has undergone numerous changes, many at the first ladies' direction. Although **ABIGAIL ADAMS** (1744-1818) was the first to live in the house, Dolley Madison was first to shape its look when, in 1809, she began

IN THE WORDS OF Rosalynn Carter (1984)

"My greatest disappointment in all the projects I worked on during the White House years was the failure of the Equal Rights Amendment to be ratified. . . . Why all the controversy and why such difficulty in giving women the protection of the Constitution that should have been theirs long ago?"

acquiring elegant furnishings and decorations for the Oval Drawing Room. Unfortunately, her efforts were lost when the British burned the house in 1814.

Since that time, each first lady has made some addition to the house. The tradition of hanging portraits of first ladies in the White House, for instance, was initiated by **JULIA GARDINER TYLER** (1820-89). **CAROLINE HARRISON** (1832-92) refurbished the house to accommodate her large, extended family and started the White House china collection. **GRACE COOLIDGE** (1879-1957) redecorated the Green Room and helped gain approval from Congress for acquiring antiques.

While most first ladies have been praised for their decorating efforts, **MARY TODD LINCOLN** (1818-82) was criticized for purchasing furnishings during the Civil War, and many felt that the dinner service ordered by Nancy Reagan was too formal and expensive, although it was paid for by private donations.

As part of her commitment to restore the White House to its original state and acquire historical furnishings for it, **JACQUELINE KENNEDY** (1929-94) formed a Fine Arts Committee for the White House. Her televised tour of the house was a widely acknowledged triumph in helping the American people feel that the president's house is also their house.

On Tour

Tours of the White House remain one of Washington's most popular tourist activities. Some highlights on the tour for the general public include the following.

• Portraits of first ladies hang on the walls of the **Ground Floor Corridor**, a grand marbled hallway with glittering glass lighting fixtures. Included are portraits of Mamie Eisenhower, Rosalynn Carter, Betty Ford, Barbara Bush, Edith Wilson, and Frances Cleveland.

• The **East Room,** which is now used primarily for state receptions and concerts, has been the site of a wide variety of activities. Abigail Adams used the room to dry her laundry. In February 1906, **ALICE ROOSEVELT,** daughter of Theodore Roosevelt, married Rep. Nicholas Longworth here. Hillary Rodham Clinton has used the room for meetings on various important issues. Hanging in the room is the large portrait of George Washington that Dolley Madison rescued in 1814, as well as a full-length portrait of **MARTHA WASHINGTON.**

Jacqueline Kennedy

• Furnished in the Empire style of 1810-30, the **Red Room** has been a favorite entertainment spot among first ladies. This room is where Dolley Madison held her popular Wednesday night socials and where Eleanor Roosevelt conducted some of her press conferences (she was the first first lady to do so). An 1804 portrait of Dolley Madison hangs on one wall and a portrait of Angelica Van Buren on another.

• The **Green Room** was refurbished especially by Jacqueline Kennedy and Pat Nixon. The exquisite green watered silk that covers the walls was originally selected by Kennedy in 1962; it has been replaced twice since then. The room has often been used as a parlor for teas and receptions and occasionally for formal dinners. In the room is a portrait of **LOUISA CATHERINE ADAMS** (1775-1852), wife of President John Quincy Adams. Louisa was born in England to American parents and is thus the only first lady born abroad.

- From the Colonnade, visitors can view the **Jacqueline Kennedy Garden** outside the Ground Floor Corridor. Lady Bird Johnson named the garden in 1965 in recognition of her predecessor's work in improving the look of the White House. Hillary Rodham Clinton was responsible for turning it into a sculpture garden, which contains temporary exhibitions of works by some of America's best 20th-century sculptors.

- The **Vermeil Room,** also known as the Gold Room, is used as a sitting room for formal occasions. On the walls are a full-length portrait of Jacqueline Kennedy, along with the portraits of Lady Bird Johnson, Pat Nixon, Nancy Reagan, and Lou Hoover. Visitors can also see the portrait of Eleanor Roosevelt if they stick their heads inside the door and look left.

- Visitors on a Congressional Tour can also see the **China Room,** where two centuries of White House state dinner services are displayed. In addition to the china, the room features a huge painting of animal lover Grace Coolidge in a long red dress with her white collie, Rob Roy, at her side. This portrait came about because President Coolidge was too busy to sit when the artist arrived, so his wife took his place.

Tours

White House tours are given Tuesdays through Saturdays from 10 am to noon. Tickets for that day's tours can be obtained at the White House Visitor's Center (1450 Pennsylvania Ave., NW) starting at 8 am and are issued on a first-come, first-served basis. Because they go extremely fast, it is advisable to arrive early.

IN THE WORDS OF Margaret Truman, daughter of Bess and Harry Truman

"No matter how different our First Ladies have been— and as individual women they have ranged from recluses to vibrant hostesses to political manipulators on a par with Machiavelli—they have all shared the unnerving experience of facing a job they did not choose."

Congressional tours are available Tuesdays through Saturdays, 8:15 am to 9 am. Tickets must be obtained in advance from a congressional representative.

In addition to touring the White House, visitors can also view exhibits of the house and its history at the White House Visitor's Center.

See also: on Madison, pp. 54, 56, 89, 104, 121; on Wilson, p. 55; on E. Roosevelt, pp. 35-37, 54, 56, 85-86, 106, 138; on Johnson, p. 55; on Ford, pp. 55, 56; on Reagan, p. 56; on Bush, pp. 54, 56, 57; on Clinton, pp. 26, 55, 57; on A. Adams, pp. 19, 54; on Lincoln, pp. 54, 55, 57, 120-21; on Kennedy, pp. 56, 125-26; on A. Roosevelt (Longworth), pp. 79, 96; on Washington, pp. 54, 68, 109, 121, 122, 132-34; on L. Adams, p. 55.

● *on this spot:* WILLARD HOTEL ●

It was 1861, soon after the beginning of the Civil War, and poet **JULIA WARD HOWE** (1819-1910) was staying at the Willard Hotel, one block from the White House, after visiting a Massachusetts army camp nearby. One night she was awakened by soldiers outside singing "John Brown's Body," a folk song honoring abolitionist Brown and his raid on Harpers Ferry in 1859. Using hotel stationery, she wrote new words to the tune that used religious images to suggest the righteousness of the military cause.

In 1862, her poem was published in the *Atlantic Monthly*. The song soon after became the anthem of the Union Army as the popular "Battle Hymn of the Republic." It is said that President Lincoln wept when he heard it.

Howe went on to serve in leadership positions in the American Woman Suffrage Association and the Woman's International Peace Association. She continued to write and publish poetry and founded the *Woman's Journal* in New England, which she edited for 20 years.

Her writing of the "Battle Hymn of the Republic" is commemorated by a plaque at the present Willard Hotel, constructed in 1901 on the site of the earlier hotel, at 1401 Pennsylvania Ave., NW.

A side from the most-visited sites in Washington, many others—perhaps lesser-known—mark the achievements and struggles of women in times past.

Whitney Sculpture

Several works by **GERTRUDE VANDERBILT WHITNEY** (1875-

Howard University

From the end of slavery in the 1860s to the guarantee of equal access to all educational institutions in the 1960s, black colleges and universities like Howard were the primary source of higher education and professional training for African-American men and women.

ALSO OF INTEREST

1942), a sculptor especially of public art, are found around the city. Her most important piece, the dramatic *Titanic Memorial* (1931), honors the 1,500 people who died when the luxury liner hit an iceberg and sank in the nation's worst maritime disaster. The memorial, an 18-foot tall male figure with outstretched arms, is at Washington Channel Park, 4th and P streets, SW.

Whitney's *Spirit of Service* (1920), depicting women helping soldiers, is at the American Red Cross headquarters, and a sculpture at the DAR complex honors its founders. In addition to her own art, Whitney helped young artists by purchasing their works and displaying them in New York City's Whitney Museum, which she founded.

Among Howard's distinguished graduates is **MARY ANN SHADD CARY** (1823-93), the daughter of free blacks in Delaware, who established schools for African-Americans in Pennsylvania and her home state. She moved to Canada in 1850 to help refugees fleeing slavery in the United States. There, she helped found an influential newspaper, known for boldly advocating independence and self-reliance. In 1869, Cary moved to Washington, where she was a grammar school teacher and principal, lectured on race relations and slavery, and supported woman suffrage. She graduated from Howard University Law School at the age of 60.

In addition to being the alma mater of Cary and many other

117

distinguished black women, Howard University is the home of the Moorland-Spingarn Research Center's Archives on African-American History and Culture. Dormitories named for notable African-American women include 18th-century poet **PHILLIS WHEATLEY** (1753-84) and the legendary **HARRIET TUBMAN** (1820-1913), who helped more than 300 slaves escape to freedom on the Underground Railroad. The university is located at 2400 6th St., NW; 202/806-6100.

Cherry Blossoms

The cherry trees around the Tidal Basin bloom for only about a week each year, but they are one of the city's top attractions—and the tenacity of several Washington woman is the reason they are there.

In the late 1800s, **ELIZA SKIDMORE** began a 24-year crusade to have the Japanese trees planted in this area of prominence. Finally, she found an ally in First Lady **HELEN HERRON TAFT** and, in 1912, Washington received 3,000 trees as a gift of friendship from Tokyo. Taft and **VISCOUNTESS CHINIDA,** wife of the Japanese ambassador, planted the first trees on the north side of the Tidal Basin in West Potomac Park.

Two decades later, when some trees were to be removed to make way for the Jefferson Memorial, a group of women threatened to chain themselves to the trees to protect them. A compromise was reached to plant more trees on the east side of the memorial to compensate for those removed.

The grove expanded again in 1965 when Washington received an additional 3,800 trees from Tokyo. The annual National Cherry Blossom Festival now draws more than 600,000 visitors every spring.

Law Enforcement Memorial

More than 100 women are honored at the National Law Enforcement Officers Memorial, which pays tribute to officers killed in the line of duty. Over half of the women served in local police agencies. The rest worked for sheriff's offices, correctional facilities, and federal agencies. The average age of the slain women is 34; the average years served is seven.

The first woman was Delaware Police Matron **MARY T. DAVIS,** who was beaten to death in 1924 while guarding a prisoner in a city jail. Currently, there are more than 60,000 female law enforcement officers nationwide, about 10 percent

of the total. The memorial is located at 605 E St., NW, between 4th and 5th Streets.

Hillwood Museum

Hillwood Museum is the 25-acre estate of heiress **MARJORIE MERRIWEATHER POST** (1887-1973), who purchased the home in 1955 and spent the last two decades of her life furnishing it.

An only child and the daughter of the founder of Postum Cereal Company, Post was well educated and, at her father's insistence, attended business meetings to prepare for running the company. However, when she inherited the business after his death, her husband took her place on the Board of Directors. Post nevertheless made key contributions, including identifying the significance of the frozen food market and urging the purchase of Birdseye.

Her interest in collecting objects from Imperial Russia began while in Moscow with her third husband, Ambassador Joseph E. Davies. Highlights of the collection include jeweled Easter eggs and other objects designed by Carl Fabergé; Russian glassware and porcelain; portraits of Peter I, Nicholas II, Elizabeth I, and Catherine the Great; ecclesiastical items of the Russian Orthodox Church; and clothes and jewelry worn by Post to society events.

The estate, at 4155 Linnean Ave., NW, closed for renovations in December 1997. When it reopens in late 1999, the space will include a new visitors center, parking structure, and exhibition space.

Joan of Arc Statue

The Joan of Arc Statue in the center of Malcolm X (also known as Meridian Hill) Park at 16th St. and Florida Ave., NW, symbolizes international friendship and unity among women.

At a very young age, **JEANNE D'ARC** (1412-31) said she heard voices instructing her to lead France into battle and convinced the leaders to allow her to do so. Her military expeditions at first proved fruitful, but when they faltered, she was captured by the enemy. Eventually, she was returned to France, where she

IN THE WORDS OF Marie Curie (1894)

"One never notices what has been done; one can only see what remains to be done."

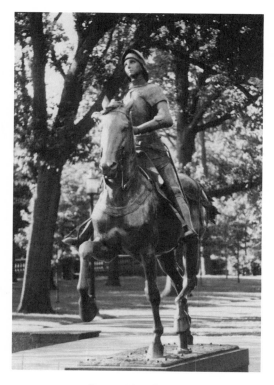

Joan of Arc Statue

was accused of being a witch and burned at the stake at 19. She was sainted in 1920.

In 1922, the women of France gave the statue to the women of the United States as a symbol of peace and justice. The nine-foot tall bronze depicts Joan seated on horseback ready for battle. Unfortunately, the sword, usually in her right hand, has been destroyed by vandals.

Black Fashion Museum

The Black Fashion Museum focuses on African-American designers and their contributions to the fashion industry.

Although temporary exhibits change every six months, a permanent display honors **ELIZABETH KECKLEY**, a seamstress who designed many of First Lady **MARY TODD LINCOLN**'s clothes.

Included in the exhibit is a royal purple velvet gown with white lace that Keckley made. It was the first colorful dress Lincoln wore after two years of mourning following the 1862 death of her son Willie. Also on display is the book Keckley wrote in 1868, *Behind the Scenes: Thirty Years a Slave, Four Years in the White House,* which provides revealing accounts of the Lincoln family.

Docent- and self-guided tours are available by appointment only. The museum is located at 2007 Vermont Ave., NW; 202/667-0744.

Nuns of the Battlefield

The bronze life-size Nuns of the Battlefield Monument at Rhode Island Ave. and M St., NW, honors nuns who cared for soldiers during the Civil War. Erected in 1924 by the Ladies Auxiliary of the Ancient Order of the Hibernians, the relief depicts 12 nuns guarded by angels of peace and patriotism. At the top, a cross is surrounded by a wreath. The relief is inscribed: "To the memory and in honor of the various orders of sisters who gave their services as nurses on battlefields and in hospitals during the Civil War."

Dumbarton House

Dumbarton House contains a collection of 18th- and 19th-century furniture, art, clothing, and other objects that belonged to the descendants of **MARTHA WASHINGTON**. Also housed there are manuscripts pertaining to **DOLLEY MADISON**'s stay at the house after the British burned the White House.

The house is the headquarters of the National Society of the Colonial Dames of America, a organization of the descendants of prerevolutionary America, founded in 1891 to preserve historical objects and provide education. Guided tours of the house at 2715 Q St., NW, are offered Tues.-Sat., 10 am-12:15 pm. It is closed Sun., the month of August, and Dec. 25-Jan. 1. Admission is by donation; students are admitted free. For information, call 202/337-2288.

IN THE WORDS OF Helen Keller (1940)

*"Life is either a daring adventure or nothing.
To keep our faces toward change and behave
like free spirits in the presence of fate
is strength undefeated."*

Washington National Cathedral

The Washington National Cathedral, a massive structure modeled on 14th-century English Gothic cathedrals, pays tribute to numerous women of achievement.

Buried there are **HELEN KELLER** (1880-1968), the brilliant blind and deaf educator and activist, and her teacher, **ANNE SULLIVAN MACY** (1866-1936). While Keller's and Macy's tombs are not accessible to the public, plaques commemorating them may be seen in the Chapel of St. Joseph of Arimathea. A carving of Keller, placed low on the wall so that blind visitors can touch it, is also included in the Women's Bay on the north outer aisle.

Banners in the cathedral honor nurse-midwife **MARY BRECKINRIDGE**, founder of the Frontier Nursing Service which provided health care to people living in remote mountain areas.

Women honored with cathedral windows include **MARTHA WASHINGTON, JOAN OF ARC, MARIE CURIE,** and **FLORENCE NIGHTINGALE**. Those recognized with needlepoint kneelers in St. John's Chapel include **SOJOURNER TRUTH, HARRIET TUBMAN, LOUISA MAY ALCOTT, HARRIET BEECHER STOWE, EMILY DICKINSON, SUSAN B. ANTHONY,** and **ELIZABETH CADY STANTON.**

The Women's Porch on the north side is a tribute to American women donated by the 1931 National Women's Committees of the Cathedral.

The cathedral, at Massachusetts and Wisconsin Ave., NW, is open 10 am-4:30 pm, Mon.-Sat. and 12:30-4:30 pm, Sun.; for more information, call 202/537-6200. Amenities for visitors include a gift shop, guided tours, daily services, choir performances, and organ recitals.

See also: on Whitney, p. 105; on Taft, pp. 56, 126; on Elizabeth I, p. 10; on Joan of Arc, p. 18; on Lincoln, pp. 54, 55, 56, 113; on Washington, pp. 54, 68, 109, 113, 132-34; on Madison, pp. 54, 56, 89, 104,110-11, 112-13, 114; on Keller, p. 81; on Breckinridge, p. 59; on Truth, pp. 19, 107; on Alcott, p. 104; on Stowe, pp. 59, 107; on Anthony, pp. 8, 12, 17, 19, 21, 59, 82, 104; on Stanton, pp. 8, 17, 19, 21, 59, 104-5.

IV. Virginia and Maryland

Arlington National Cemetery is the final resting place of more than 250,000 individuals and their dependents who dedicated their lives to military and other national service. Established by the U.S. Congress in 1864 as a national burial site for soldiers killed during the Civil War, the

Shortly thereafter, Sgt. **DANIELLE WILSON** became the first African-American woman to do so.

The ceremonial changing of the guard symbolizes the nation's constant vigilance over the tomb and gratitude for those who made the ultimate sacrifice for their country. The four soldiers entombed there—one

ARLINGTON NATIONAL CEMETERY

612-acre site is now marked by seemingly unending rows of marble headstones in perfect formation, along with numerous distinctive memorials to groups and individuals.

A must-see is the Women in Military Service for America Memorial at the cemetery's gateway entrance. The memorial and education center are dedicated to women who have served in or with the U.S. military (see pp. 148-49 for details).

One of the cemetery's most popular sites, the Tomb of the Unknown Soldier, became a place where women's history was made in March 1996, when Sgt. **HEATHER LYNN JOHNSEN** became the first female soldier to guard the tomb.

each from World War I, World War II, and the Korean and Vietnam wars—represent all the men and women who lost their lives in those conflicts.

 Location: on the Arlington side of Memorial Bridge, about 3/4 mile from the Lincoln Memorial
Metro: Arlington Cemetery
Phone: 703/607-8052
Hours: April-Sept., 8 am-7 pm, daily; Oct.-March, 8 am-5 pm, daily
Amenities: bus tours, grave location assistance, gift shop

Notable Grave Sites

Among women buried in the cemetery, probably the best known is **JACQUELINE KENNEDY ONASSIS**, whose grave is beside that of her first husband, President John F. Kennedy, and her two infant children in Section 45. Not only was Onassis a beloved first lady, but she also achieved prominence in her own right as a supporter of the arts and a book editor.

Other notable women buried in the cemetery include:

• **VINNIE REAM HOXIE**, sculptor of famous statues of President Lincoln and others, is interred in Section 3 with her husband, Lt. Richard Hoxie. The statue on the memorial is a bronze replica of her sculpture of **SAPPHO**. Its base includes a relief of Hoxie's face.

• **HELEN HERRON TAFT**, wife of President William Howard Taft, was instrumental in planting the Japanese cherry trees around the Tidal Basin. She is buried alongside her husband in Section 30.

• **MARY ROBERTS RINEHART** (1876-1958), an acclaimed mystery writer who became one of the first female war correspondents when *The Saturday Evening Post* sent her to Europe to cover World War I. She is buried in Section 1.

• Adm. **GRACE HOPPER** (1906-93), was a computer genius, responsible for the creation of COBOL, one of the most widely used computer languages. Hopper was so crucial to the workings of the U.S. armed forces that she was called back three times after she retired. She is interred in Section 59.

• Lt. Comdr. **BARBARA RAINEY** (1948-82) was the first woman to be qualified as a "Top Gun," an elite Navy pilot. She died during a training mission. Her grave is in Section 6.

• Maj. **MARIE TERESA ROSSI** (1959-91), an Army helicopter pilot, was the first woman to fly troops into combat. She was killed in Operation Desert Storm in the Persian Gulf and is buried in Section 8.

IN THE WORDS OF Grace Hopper (1986)

"A ship in port is safe, but that's not what ships are built for."

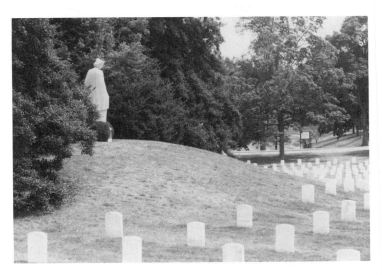

Statue of Jane Delano overlooking headstones.

Nurses Memorials

Until recently, most women who served in wars were nurses; consequently, many memorials in the cemetery honor those women and their service. The Nurses Memorial, located in Section 21, is dedicated to the hundreds of nurses who aided American soldiers from 1938 to the present. Overlooking the burial area is a ten-foot marble statue of **JANE DELANO** (1862-1919) in her nursing uniform. The statue appears to be standing guard over rows of headstones—including her own—from the top of a sloping hill.

Delano made significant contributions to the preparation and readiness of nurses for World War I. Before the war, Delano had discovered ways to contend with the outbreaks of yellow fever and scarlet fever and was director of the School of Nursing at Bellevue Hospital in New York and superintendent of the Army Nurse Corps.

But it was her role as organizer of the Red Cross nursing corps in World War I that endeared her to the nation. She organized and implemented a program to have 8,000 nurses ready to assist at the outbreak of the war, a crucial strategy for the survival of American soldiers. Soon after the war ended, Delano wanted

to gain first-hand knowledge of the welfare of her nurses, so she visited France to inspect nursing facilities. While there, she grew weaker from a lingering illness and died in 1919.

Also in this section, the Spanish-American War Nurses Memorial honors nurses who served in this war at the turn of the 20th century. The Spanish-American War was the first time that nurses were organized for deployment to battlefields to tend to injured and dying soldiers.

The granite memorial was commissioned by the Society of Spanish-American War Nurses, who dedicated it to their "brave comrades." The society's insignia, the Maltese Cross, sits atop the stone.

Other individual nurses commemorated in the cemetery include: **ANITA NEWCOMB McGEE** (d.1940), founder of the Army Nurse Corps, was buried with full military honors in Section 1. Known as a tireless worker and brilliant organizer, McGee also was a surgeon.

In Section 1 as well is the grave of **JULIET OPIE HOPKINS** (1818-90), one of the most beloved nurses of the Confederate South. She braved the dangers of Civil War battlefields to tend to injured and dying soldiers and was herself struck in the leg by a bullet in 1862.

For More Information

The visitor's center, located on Memorial Drive, provides maps of the cemetery and information. Cemetery staff will provide directions to specific graves if visitors have the individual's name and service branch. Bus tours originate at the visitor's center between 8:30 am and 4:30 pm, Sept.-June, and until 6:30 pm in July and August.

See also: on Onassis, pp. 56, 113, 114, 115; on Hoxie, pp. 22-23, 95; on Taft, pp. 56, 118; on Hopper, pp. 144-46; on Delano, p. 81.

T he Clara Barton National Historic Site is a memorial to the early years of the American Red Cross and the house's chief occupant, humanitarian **CLARA BARTON** (1821-1912). Barton is best known for founding the American Red Cross and serving as its president for two decades.

Then, the Civil War broke out. Upon hearing that the troops of the 6th Massachusetts of her home county had been caught in a riot while passing through Baltimore, she went to see if she could help. Some soldiers had died, she found, and the many who were wounded did not have even basic supplies. Barton

CLARA BARTON
NATIONAL HISTORIC SITE

But her lifetime of service extended into many areas.

Born in North Oxford, Massachusetts, Barton had her first nursing experience as a child when she cared for her older brother during his two years' convalescence from a serious injury. At 18, she started teaching and later established a free public school in Bordentown, New Jersey. When the town objected to a female principal and put a man in charge, however, she resigned and moved to Washington, D.C. There, she became a clerk at the Patent Office. Her service there was also trying, for her male colleagues were frequently rude to her and spit tobacco juice or blew smoke at her.

wrote to their families to ask for help with acquiring necessities. This act launched her into years of ministering to wounded soldiers. For her tireless efforts, she became known as the "Angel of the Battlefield."

After the war, Barton continued to aid soldiers and their families. She

Location:
5801 Oxford Rd.,
Glen Echo, MD
Phone: 301/492-6245
Hours: 10 am-5 pm, daily
Amenities: visitors' center with bookstore, picnic area, tours
Entrance fee

was responsible for identifying thousands of missing and dead soldiers and establishing a national cemetery for war victims at Andersonville, Georgia, the site of a notorious prisoner of war camp. She also lectured widely as a strong advocate of rights for women and African-Americans.

Barton's tireless efforts, however, strained her health, and she had a nervous breakdown in 1869. While recuperating in Europe, she learned about the International Red Cross and soon began assisting victims of the Franco-Prussian War.

Her involvement with the International Red Cross sparked her interest in creating an American branch. When she returned to the United States, she pressed political leaders to approve the Treaty of Geneva, which established units of the International Red Cross. In 1882, it was approved, and the American Red Cross was founded with Barton as its first president.

During her 23-year tenure, she made humanitarian aid available not only in wartime, but also during di-sasters and other peacetime tragedies. In all, she assisted in the relief of 18 disasters, including the Johnstown Flood of 1889.

Barton pushed on even in her later years, including organizing relief efforts during the Spanish-American War when she was in her 70s. But there was growing dissatisfaction with her leadership of the Red Cross. Many newer members criticized what they saw as her old-fashioned management style and believed she could not lead the organization effectively into the future. Barton gave in to the pressures in 1904 and resigned, but she continued to live in the Glen Echo house.

In her 80s, she founded the National First Aid Association of America. She died in Glen Echo on April 12, 1912, at the age of 91.

Barton's House

The restored three-story Victorian house overlooking the Potomac Valley was the organization's first permanent headquarters. It functioned as meeting place, warehouse for

IN THE WORDS OF Clara Barton

"If I can't be a soldier, I'll help soldiers."

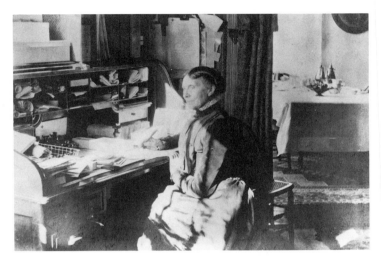

Clara Barton at her desk

supplies for relief efforts at home and abroad, and office and home to Barton and her volunteers. One-third of the contents are original pieces from when Barton lived there.

The ground floor hallway contains rows of specially constructed, three-feet-deep storage closets used to stockpile tents, clothing, shovels, and medical and other supplies. On display are an Austria-Hungary crest and a flag of Turkey, a small representation of Barton's collection of more than 50 flags from countries that had ratified the Treaty of Geneva.

Also on the ground floor are the Red Cross offices, set up as they were in the organization's early years. Barton's office contains a rolltop desk, filing cabinet, papers, and books. The volunteers' office is cluttered with papers and contains typewriters and a graphaphone, which Barton used for dictation.

On the second and third floors are more storage spaces and bedrooms, including Barton's on the second floor where she died.

The house is shown by tour only, beginning each hour on the hour. The last tour begins at 4 pm.

See also: on Barton, pp. 11, 19, 80-81.

In the mid-1800s, a pioneering group of women came together with the sole mission of preserving Mount Vernon, the estate of George and Martha Washington.

After a relative had failed to persuade the federal government or the Commonwealth of Virginia to purchase and preserve the property, ANN PAMELA CUNNINGHAM (1816-1875) of South Carolina stepped in. In 1853, despite a debilitating and painful spinal handicap and being told her efforts were inappropriate for a lady, Cunningham founded the Mount Vernon Ladies' Association of the Union to raise money, and five years later, the

MOUNT VERNON

✔ **Location:** at the southern end of the George Washington Parkway in Virginia, 16 miles from downtown Washington; the route is well marked.
Phone: 703/780-2000; TDD: 703/799-8121
Hours: Apr.-Aug., 8 am-5 pm; Mar., Sept., Oct., 9 am-5 pm; Nov.-Feb., 9 am-4 pm, all daily
Amenities: tours, special programs and events, four-acre farm, two museums, two gift shops, restaurant, snack bar, senior citizen discounts, parking lots. Leashed dogs are allowed on the grounds.
Entrance fee

association purchased 200 acres of the estate for $200,000.

The association was the first national historic preservation organization and the first female organization to receive a charter from Congress. These women's work at Mount Vernon set a precedent for the preservation of the country's heritage.

The First First Lady
MARTHA CUSTIS WASHINGTON (1731-1802) had been well prepared for life at Mount Vernon. As a girl, she was taught domestic subjects, such as cooking, gardening, housekeeping, and the art of herbs and medicine. In addition, she was trained in good manners, music, dancing, and even the art of

conversation. At 17, Martha married her first husband, Daniel Parke Custis of Williamsburg, who was 23 years her senior. Of their four children, only two survived early childhood. When Custis died of a heart condition, Martha became one of the wealthiest widows in Virginia.

Martha Custis married George Washington in 1759 and joined him at his estate. Mount Vernon, inherited from George's older brother, was their primary residence until their deaths, although George's service first as commander in chief during the Revolutionary War and then as president kept them away from their beloved home for years at a time. George died in 1799, and Martha three years later. Both are buried in a tomb on the estate.

The House and Grounds

The estate overlooking the Potomac River was restored according to a detailed inventory taken shortly after George Washington's death. The restoration mirrors the inventory down to the brightly colored paint and wallpaper and placement of the furnishings, many of which were owned by the Washingtons.

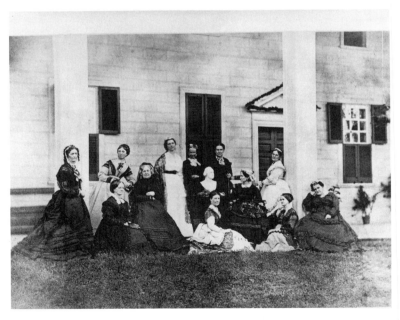

Mount Vernon Ladies Association at Mount Vernon in 1820;
Cunningham is fourth from right, seated in chair.

On the first floor, a porcelain tea and dinner service Martha used for entertaining is on view in the West Parlor. Next door, the Music Room, also referred to as the Little Parlor, contains Martha's upholstered chair where she sat doing needlepoint.

The Music Room was also frequently used by **NELLY CUSTIS,** Martha's youngest granddaughter. On display with other instruments is Nelly's harpsichord, which George imported from London. Martha was known as a tough supervisor of her granddaughter's practices and, according to one of Nelly's letters, once even reduced the child to tears. After the death of Martha's son in the Revolutionary War, she and George had brought Nelly and her brother, George, to live at Mount Vernon.

The Washingtons' bedroom, on the second floor, was also the place from which Martha ran the vast household. The desk contains the leather key basket she carried during her daily inspections of the rooms and buildings. Her dressing table has a Chinese lacquered "dressing glass," or mirror, that was made in Virginia. Portraits of Martha and of her four grandchildren are on the walls.

Martha oversaw the selection of furnishings for the bedroom she and her husband shared, including the design of the bed. This fact is notable because, in the 18th century, home decorations were typically chosen by men, and George selected colors and furnishings for the rest of the house.

On the third floor, which is open only during December and on special occasions, visitors can view a trunk that Martha used when she visited her husband's northern encampments during the Revolutionary War. A note on the lid from one of Martha's granddaughters describes both her sadness watching her grandmother pack the trunk before going away and her excitement watching her unpack it on her return.

Martha's jewelry, including a garnet stickpin, enamel and pearl ring, and gold necklaces and earrings, and other possessions are on display in the Washington Family Museum, located near the mansion. Also in the museum is a bronze plaque commemorating the efforts of Ann Pamela Cunningham in making all this possible.

See also: on Washington, pp. 54, 68, 109, 113, 121, 122.

W omen journalists have been condescendingly referred to as "Front Page Girls," "Stunt Girls," or "Sob Sisters" at various times in the past. Yet they have earned respect in one of the most competitive professions. Their accomplishments as well as significant media events that have includes an option to listen to media history related to women.

The exhibit is set up chronologically. The main section consists of a timeline running along the wall at eye level, divided into centuries at first and then into decades, and featuring photos of notable journalists of each period. Underneath the timeline are

THE NEWSEUM

affected women are explored at the Newseum, one of Washington's newest and most interactive museums.

Women in News History

Many notable women journalists are featured in the museum's central exhibit, the "News History Gallery" on the third floor. In addition to displaying ancient documentation techniques and early press equipment, this exhibit reviews significant news stories and media turning points from the 1600s to the present through artifacts, memorabilia, photographs, and multimedia displays. While some international events are included, the focus is on U.S. history. An audiotape tour—available just outside the gallery entrance—

display cases organized around various topics, framed documents, and large flat drawers containing printed materials corresponding to each period.

Women highlighted in the exhibit range from the virtually unknown to the megastars of the 1990s.

 Location:
1101 Wilson Blvd.,
Arlington, VA
Metro: Rosslyn
Phone: 703/284-3544 or
888/NEWSEUM
Hours: 10 am-5 pm, Wed.-
Sun.; closed major holidays
Amenities: audio tours, gift
shop, News Byte Cafe
Web site: www.newseum.org

Among the women whose photos and brief biographies appear in the timeline are the following:

• **MARY KATHERINE GODDARD** (1738-1816), who helped publish her brother's newspapers in Colonial America.

• **SARAH JOSEPHA HALE** (1788-1879), who wrote "Mary Had a Little Lamb" and edited *Godey's Lady's Book*, the top women's publication in the nation, for 40 years.

• **FANNY FERN** (1811-72), pen name of Sara Willis Parton, a popular *New York Ledger* columnist, who wrote about such taboo subjects as birth control and venereal disease.

• **MARGARET FULLER** (1810-50), the first female journalist hired by a major U.S. daily newspaper, the *New York Tribune*. In 1846, Fuller also became the first female foreign correspondent when her paper sent her to Europe. In addition, she was author of the book *Woman in the 19th Century*.

• **AMELIA BLOOMER** (1818-94), who started *The Lily* to promote a woman's right to wear pants. The first women's pants were

In this self-portrait, Frances Johnston mocks Victorian norms by drinking, smoking, and revealing her stockinged leg.

thus called "bloomers." She later moved on from the cause of fashion reform to suffrage, divorce reform, and women's property rights.

• **MARY BAKER EDDY** (1821-1910), who in 1908 founded the *Christian Science Monitor* to focus on news analysis.

• **FRANCES JOHNSTON** (1864-1952), a pioneering photographer known for her pictures of political leaders, the Spanish-American War, the World's Fair, Pennsylvania miners, and rural Southern life.

• **IDA B. WELLS** (1862-1931), who put her job and her life on the line by writing searing editorials condemning the lynching of African-Americans in her newspapers, *Memphis Free Speech* and *Headlight.* Mobs closed down her papers, but her efforts were instrumental in eventually forcing authorities to enforce anti-lynching laws.

• **LUCILE BLUFORD** (1911-), who as an African-American was refused admission to the University of Missouri School of Journalism in 1939. She went instead to all-black Lincoln University, and 50 years later, she owned, published, and edited the *Kansas City Call*. The University of Missouri later awarded her an honorary doctorate.

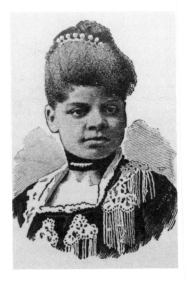

Ida B. Wells

• **HELEN THOMAS** (1920-), long-time UPI White House correspondent, known as dean of the White House press corps.

• **NANCY HICKS MAYNARD** (1946-), who quit her reporting job at the *New York Times* to found the *Oakland Tribune* with her husband and push for newsroom diversity.

In addition to the permanent photographs, small television screens spaced along the timeline flash images and short biographies of other journalists. Among the women who appear are: **LORENA HICKOK** (1893-1968), an AP reporter who

convinced her close friend, First Lady **ELEANOR ROOSEVELT,** to hold press conferences exclusively for female journalists; **BARBARA WALTERS** (1931-), America's first regular female network news anchor; **SUSAN STAMBERG** (1938-), one of the founders of National Public Radio; and talk-show host and media entrepreneur **OPRAH WINFREY** (1954-), one of the most powerful women ever in entertainment history.

In the display cases beneath the timeline are several small exhibits about women journalists and news events related to women. One features the around-the-world-in-72-days trip taken in 1889-90 by sensationalist journalist **NELLY BLY** (1864-1922). Bly (whose real name was Elizabeth Cochrane Seaman) got her start at Joseph Pulitzer's *The World* in 1885 after writing to denounce an editorial opposing suffrage and careers for women. In the most extreme example of her undercover style, Bly once committed herself to a mental asylum to report on neglect and abuse there.

Under the heading "Whose news is it?," display cases in the 1900 section show how women took the initiative to document and promote the suffrage movement when mainstream newspapers would not. Items on display include copies of the *Woman's Journal and Suffrage News*. After the 19th Amendment giving women the right to vote was ratified in 1920, the newspaper became *The Woman Citizen*. Also in the exhibit are suffrage buttons, playing cards, ribbons, and badges.

The "The World Goes to War" display includes the large, heavy camera used by **MARGARET BOURKE-WHITE** (1904-71), the first woman photojournalist certified to cover World War II. In addition to flying combat missions over Italy, Russia, and North Africa, Bourke-White witnessed the liberation of Buchenwald concentration camp in 1945; one of her photographs from that chilling day is on display.

IN THE WORDS OF Margaret Bourke-White (1963)

*"Nothing attracts me like a closed door.
I cannot let my camera rest
until I have pried it open."*

From more recent times, consider the courage of **KATHARINE GRAHAM** (1917-), publisher of *The Washington Post.* In 1972, Attorney General John Mitchell threatened that Graham would "get her tit caught in a big fat wringer" if she published articles exposing the Nixon administration's Watergate scandal. Graham went to press with the story, and Mitchell went to jail. On display is Graham's gold Watergate necklace, with a breast below a wringer, given to her by friends during that tense time in U.S. history.

Also on view is the "target vest" worn by Algerian television reporter and producer **HORRIA SAIHI** (1952-) when she demonstrated in 1995 against the murders of Algerian journalists. Saihi had become a target of Islamic fundamentalists because she reported political news. The vest, which Saihi made, depicts a bull's-eye symbol and simulated blood spatters.

Not to be missed is the display "Women Make News" in the 1970s section, which documents significant advances women have made toward pay equity, newsroom clout, and better access to sources.

The exhibit includes the press passes and a photograph of reporter **MELISSA LUDTKE** who made

*Katharine Graham's
Watergate necklace*

news in 1977 after she was barred from the New York Yankees locker room while trying to get an interview for *Sports Illustrated.* Ludtke sued for the right for women reporters to enter locker rooms and won.

The display case also contains memorabilia from the 1978 lawsuit against the *New York Times* for gender bias in the newsroom.

Other Tributes

Outside the museum, Freedom Park has a display of eight symbols that represent Americans' fight for freedom. One of those features replicas of banners from the suffrage movement, emblazoned with slogans such as "Votes for Women."

On the connector walkway is "The Freedom Forum Journalists Memorial," a powerful, ethereal tribute to journalists from around the world who died as a result of their profession. Names of more than 900 journalists and photographers are listed on huge neon-tinted glass panels, one for each year. Of the nearly 50 female journalists on the list, some were killed while covering conflicts, others as a result of investigative work that uncovered corruption or other wrongdoing, and still others simply for being members of the media. Included are:

• **MARGUERITE HIGGINS** (d. 1966), a war correspondent for *Newsday,* died of a rare tropical ailment she contracted while on assignment in Asia.

• **RACHIDA HAMMADI** (d. 1995), a television investigative reporter who had exposed crimes against women, was gunned down by the radical Armed Islamic Group.

• **VERONICA GUERIN** (d. 1996), an Irish investigative reporter, was shot while trying to expose organized crime for the *Sunday Independent.*

In a kiosk next to the memorial is a computer, on which visitors can type in a name on the list and then touch the name when it appears on the screen to get more information about the journalist and how he or she died.

Farther along the walkway is a tribute to six pioneers of journalism. One of them—the sole woman—is anti-lynching crusader Ida B. Wells.

Back inside the museum, a continuously running film includes stories of women in the media and women making news, and a database provides short biographies of more than 500 newspeople. On the second floor, female journalists answer questions about their careers at the "Interview a Journalist" computers.

The museum also features a video wall made up of the day's news stories in newspapers from all 50 states and countries around the world. And visitors who think of broadcasting as a career option can try their hand at the TV anchor desk and receive a complimentary videotape of the performance.

See also: on Roosevelt, pp. 35-37, 54, 56, 85-86, 106, 112, 115.

Not only did Dr. **MARY E. WALKER** (1832-1919) have to struggle for the right to attend wounded Union soldiers on Civil War battlefields, but she also had to contend with criticism from those who denied that a woman could be a competent surgeon.

Trained at Syracuse Medical

campaign combined with recommendations from some male colleagues led to success and she was given a paid civilian appointment as assistant surgeon.

Soon afterwards, however, Walker was captured by the Confederates and endured four months as a prisoner of war. Upon her release, she

THE PENTAGON

College, considered a "non-regular" school because it accepted female students, Walker had been practicing medicine for five years in New York when she arrived in Washington at the outbreak of the Civil War. As casualties mounted and the demand for medical personnel increased, the government employed more and more surgeons for battlefield service. Yet the best Walker could do, and that after much effort, was to persuade officials to let her serve as a volunteer surgeon.

Walker spent three years at army camps, often dressing in men's clothing, which she said was more comfortable and practical than the layered petticoats worn by women. At last, her persistent lobbying

requested and was given the position of Surgeon-in-Charge of Female Prisoners at the Louisville (Ky.) Prison, although protests from both Union soldiers and Confederate women prisoners who lacked confidence in a female surgeon soon forced her to ask for a reassignment. At her request, she was sent again to the front where she served until the war ended.

 Location: Boundary Channel Drive exit on I-395 South
Metro: Pentagon
Phone: 703/695-1776
Hours: 9:30 am-3:30 pm, Mon.-Fri. Closed weekends and federal holidays.
Amenities: guided tours

Dr. Mary E. Walker wearing her medal

After the war, Walker was denied a commission as a peacetime surgeon, a move she protested loudly, But in November 1865, President Andrew Johnson awarded her the Congressional Medal of Honor. She was the first and still the only woman to receive this honor. Walker was so pleased with this long-overdue recognition of her work that she wore the medal every day.

Two years before her death in 1919, however, the government revised requirements for the honor, making it mandatory that recipients be members of the armed forces, and revoked the medals awarded to Walker and 910 others. Six decades later, the Secretary of the Army reversed the decision and restored Walker's medal to her family.

This medal is on display at the Pentagon, along with numerous other objects chronicling contributions women have made to America's defense. Starting with World War I, women were allowed to join some branches of the armed forces, but mostly continued to serve as nurses and office workers.

World War II, however, was a real turning point: It launched women into additional service areas and opened to them the U.S. Army, where they served in combat support roles. Groups created specifically for women included the WASPs (Women Army Service Pilots), who flew support flights to free male pilots for combat.

It wasn't until 1967, however, that women were integrated into the general ranks and, under the provisions of Public Law 90-130, received equal pay and retirement and access to higher ranks.

Today, even though women are still barred from some combat roles, they have made it to the upper service levels. In addition, in 1993 Dr. **SHEILA E. WIDNALL** became Secretary of the Air Force, the first woman to hold such a high civilian position with the U.S. military.

Touring the Pentagon

Visitors can learn about women's involvement in military service by taking the public tour at the Pentagon, the huge five-sided building which, at 6 1/2 million square feet, is the largest single-structure office building in the world.

Walker's Medal of Honor and many other artifacts can be seen in the "Women's Military Corridor," located near the end of the tour. The corridor contains a row of display cases documenting women's involvement with the military from Revolutionary times to the present. Although this area is only a quick stop on the tour, highlights include the following:

• A miniature replica of the Vietnam Women's Memorial is in the first display case. This statue of three nurses near the Vietnam Veterans Memorial on the Mall honors the

IN THE WORDS OF Mary Walker (1867)

"A woman reasons by telegraph, and his [a man's] stage-coach reasoning cannot keep pace with hers."

11,000 women who served in Vietnam and more than 265,000 who served during the war years,

• The second display case details women's participation in the Revolutionary War, the Civil War, and the Spanish-American War. Included are such objects as clothing, hats, money, plates, photographs, and short biographies.

• The third display case documents women's military service in World War I, after they were allowed to enlist in the Navy, Marines, and Coast Guard, mostly as nurses and in other support roles. Referred to as "Yeomanettes," women who served as nurses overseas numbered about 10,000. Medals, uniforms, and other memorabilia are displayed.

• With World War II, women were able to serve in all branches of the armed forces and take an active role in the defense of their country. Four display cases holding uniforms, medals, photographs, letters of commendation, and memorabilia are devoted to women's participation during this time.

A small exhibit commemorates the prisoners of war of the Navy Nurse Corps. These 11 female nurses spent 37 months in prison camps in Japan and the Philippines before being freed in 1945.

In the same case is a Red Cross supply chest with food and other necessities still inside, as well as a display on **RUTH M. GARDINER,** the first Army nurse to be killed in the line of duty. A letter in the next case from Gen. Douglas MacArthur commends the Women's Army Corps (WACs): "No finer soldiers," he wrote, "ever served under my command than the WACs."

• Among items in the display on women's involvement in sea services is a photograph of the *USS Higbee*, a Gearing-class destroyer named for **LENAH SUTCLIFFE HIGBEE,** Second Lieutenant of the Navy Nurse Corps.

• The last two cases hold uniforms and personal belongings of other military women of achievement. Special tribute is paid to Adm. **GRACE HOPPER** (1906-93), a computer genius who created the COBOL computer language, which paved the way for user-friendly computer formats.

A mathematician by training, Hopper was awarded the National Medal of Technology in 1991. In 1982 at the age of 75, she became the oldest officer on active duty. She had tried to retire on three occasions, but was called back each time for her computer expertise. According to the Pentagon, Hopper was responsible for coining the term "computer bug." After a malfunction, she had taken apart her computer and found a moth inside. A coworker walking by asked her what she was doing, and she replied that she was "de-bugging her computer."

In addition to the Women's Military Corridor, other points of interest on the tour include the office of Dr. Sheila Widnall, Secretary of the U.S. Air Force, and in the "Hall of Heroes," the name plate of Dr. Mary Walker, the only woman out of 3,408 individuals honored with a Medal of Honor for bravery and heroism above and beyond the call of duty.

To view the Women's Military Corridor, visitors must take a 1 1/2-hour guided tour, which begins every half hour at the public entrance.

See also: on Walker, p. 149; on Hopper, p. 126.

G uilty or innocent? We may never know for certain. But, for her alleged role in the assassination of President Abraham Lincoln, **MARY E. SURRATT** (1823-65) became the first woman executed by the U.S. government. To this day, she remains a controversial figure in American and boardinghouse for the area. After her husband died in 1862, Mary ran the tavern for two years. When financial problems arose, she leased the farm and moved to Washington, where she ran a boardinghouse on H Street, NW.

Visitors to the Washington house included Mary's son, John Jr., a

SURRATT HOUSE MUSEUM

history. Some believe Surratt was an unknowing accomplice; others point to convincing evidence of her guilt. Her life is documented at the Surratt House Museum.

Mary and her husband owned a 300-acre farm that served as home to them and their three children and as tavern, polling place, post office,

✓ **Location:** 9110 Brandywine Rd., Clinton, MD (3 miles from Route 5 exit of I-95 north in Maryland)
Phone: 301/868-1121
Hours: 11 am-3 pm, Thurs.-Fri.; noon-4 pm, Sat.-Sun.
Amenities: gift shop, tours, research library, picnic area

Confederate agent, and the actor John Wilkes Booth. It is believed they met there to plan the kidnaping of President Lincoln, which they attempted in March 1865 but failed. Whether Mary Surratt was aware of these discussions or played any role in the conspiracy has never been proven.

On April 14, 1865, after Booth shot Lincoln at Ford's Theatre, he appeared at the tavern and picked up some guns. Earlier, Mary had sent a message to one of her tenants telling him to get the "shooting irons" ready because someone would be coming for them that night. She later said that she delivered the message at Booth's request but did not know what he had done.

On April 26, Booth was found, shot, and killed in Front Royal, Virginia, and Mary Surratt and three others were arrested in Washington. Her son, who was in New York at the time of the assassination, fled to Canada.

A military commission found Surratt and three others guilty for their roles in the assassination and sentenced them to hang. No one believed that a woman would be executed, but President Andrew Johnson did not respond to Surratt's daughter's plea for clemency.

On July 7, 1865, Surratt and the men were read their death warrants, bound, hooded, and hanged in the courtyard of the Arsenal Penitentiary (now Fort McNair, in southwest Washington). After 30 minutes, Surratt's body was cut loose and buried on the grounds.

The Surratt House Museum does not take a position on the guilt or innocence of Mary Surratt, according to Laurie Verge, museum director. Rather, it serves as another page in the story of the Civil War. Verge points out that the museum also shows how the war led women into new roles—nursing, for example, and jobs in industry and education. Afterward, Verge says, women refused to return to what one called her "chimney corner life."

The museum contains Surratt's parlor table and ornate writing desk. In the visitors center are her watch, eyeglasses, and family pictures, and her son's embroidered handkerchief. Guides dressed in period clothing conduct tours.

After many years of being privately owned, the Surratt House was donated in 1965 to the Maryland-National Capital Park and Planning Commission, which restored it as a historic house museum and opened it to the public in 1976. Surratt's Washington boardinghouse is now a Chinese restaurant. Her remains have been reburied at Mt. Olivet Cemetery, 1300 Bladensburg Rd., in northeast Washington.

Although the Washington area is home to numerous memorials honoring military service, until recently none existed solely to commemorate the 1.8 million women who have served in the defense of America.

That omission generated a 12-year effort led by retired Air Force entrance to Arlington National Cemetery honors all women who have served in or with the armed forces since the American Revolution.

"Women have served our country for more than two centuries, but they have never really been recognized," says Vaught. "If you look in history books, you'll find very little,

WOMEN IN MILITARY SERVICE FOR AMERICA MEMORIAL

Brig. Gen. **WILMA VAUGHT**, whose dream of a tribute to these women became reality when the Women in Military Service for America Memorial was dedicated in October 1997. The majestic white granite memorial at the main

> ✓ **Location:** entrance to Arlington National Cemetery
> **Metro:** Arlington Cemetery
> **Phone:** 703/533-1155, 800/222-2294
> **Hours:** 8 am-5 pm, daily (winter); 8 am-7 pm, daily (summer); closed Christmas
> **Amenities:** gift shop
> **Web site:** www.wimsa.org

if anything, about their contributions. While their service may not have been critical to victory in the combat arena, they were called upon by their country to serve in virtually every crisis. Now, at long last, the nation is paying tribute and assuring that their stories are heard."

Like the long-running attempt to feature women in historical accounts, the memorial was long in the making. In 1985, the Women in Military Service for America Memorial Foundation was established, and the following year Congress authorized a memorial to be built on federal land in the Washington area. In 1988, the Arlington National Cemetery gateway was approved as the site, and the

148

design was selected in a national competition. The foundation raised the required $21.5 million from a federal grant, sale of commemorative coins, and donations from corporations, foundations, veterans groups, individual veterans, and others.

Inside the building is a gallery with 16 exhibit alcoves, a 196-seat theater, and an interactive computer register with names, photographs, and biographies of women registered. Among them are **MARGARET E. BAILEY,** who served from 1944 until 1971 and was the first African-American nurse to attain the rank of lieutenant colonel and then colonel in the Army; and **CARMEN JOHNSON,** an Army intelligence officer during World War II who spent five years in Japan after the war, teaching women about democracy and equal rights.

Also inside the building is the Hall of Honor, which recognizes women who have served with particular sacrifice, including those who were killed in action or were prisoners of war. Among those featured is Dr. **MARY WALKER**, a battlefield physician during the Civil War and the nation's only woman recipient of the Congressional Medal of Honor.

The design incorporates the previously existing structures of the cemetery gateway, including the historic Grand Hemicycle. From the upper level, visitors can take in the panoramic view of the nation's capital and Arlington Cemetery.

The education center's ceiling is composed of 130 glass tablets, 11 of which have been engraved with quotations from servicewomen. The Court of Valor on the lower plaza features a reflecting pool and fountain.

The foundation is continuing its search for women who have served in or with the U.S. military. For information on how to register yourself, a relative, or friend, contact the Women in Military Service for America Memorial Foundation, Dept. 560, Washington, DC 20042-0560; 703-533-1155.

See also: on Walker, pp. 141-42, 143, 145.

IN THE WORDS OF Beatrice Hood Stroup, during World War II

"It isn't just my brother's country, or my husband's country, it's my country as well. And so the war wasn't just their war, it was my war. And I needed to serve in it."

SUGGESTIONS FOR FURTHER READING

General Works: Women's History

Alonso, Harriet Hyman. *Peace as a Women's Issue: A History of the U.S. Movement for World Peace and Women's Rights.* Syracuse, N.Y.: Syracuse University Press, 1993.

Barker-Benfield, G. J., and Catherine Clinton. *Portraits of American Women: From Settlement to the Present.* New York: St. Martin's Press, 1991.

Blair, Karen J. *The Clubwoman as Feminist: True Womanhood Redefined, 1868-1914.* New York: Holmes and Maier, 1980.

Chafe, William. *The American Woman: Her Changing Social, Economic, and Political Roles.* New York: Oxford University Press, 1972.

Conway, Jill Ker, ed. *Written by Herself: Autobiographies of American Women, an Anthology.* New York: Vintage, 1992.

Davis, Elizabeth. *Lifting as They Climb: The National Association of Colored Women.* Washington, D.C.: National Association of Colored Women, 1833.

DuBois, Ellen. *Feminism and Suffrage: The Emergence of an Independent Woman's Movement in America, 1848-1869.* Ithaca, N.Y.: Cornell University Press, 1979.

Evans, Sara M. *Born for Liberty: A History of Women in America.* New York: The Free Press, 1989.

Flexner, Eleanor. *Century of Struggle: The Woman's Rights Movement in the United States.* Cambridge: Belknap Press of Harvard University Press, 1996.

Gordon, Linda. *Women's Bodies, Women's Right: A Social History of Birth Control in America.* New York: Penguin Books, 1976.

Guy-Sheftall, Beverly, ed. *Words of Fire: An Anthology of African-American Feminist Thought.* New York: The New Press, 1995.

Heilbrun, Carolyn G. *Writing a Woman's Life.* New York: Ballantine, 1988.

Hine, Darlene Clark, Elsa Barkley Brown, and Rosalyn Terbog-Penn, eds. *Black Women in America.* Indianapolis: Indiana University Press, 1994.

Hudak, Leona M. *Early American Women Printers and Publishers, 1639-1820.* Metuchen, N.J.: Scarecrow Press, 1978.

Keetley, Dawn, and John Pettegrew, eds. *Public Women, Public Words: A Documentary History of American Feminism.* Vol. I: Beginnings to 1900. Madison, Wisc.: Madison House, 1997.

Kerber, Linda K., Alice Kessler-Harris, and Kathryn Kish Sklar, eds. *U.S. History as Women's History: New Feminist Essays.* Chapel Hill: University of North Carolina Press, 1995.

Kerber, Linda K., and Jane Sherron De Hart, eds. *Women's America: Refocusing the Past.* 4th ed. New York: Oxford University Press, 1995.

Kraditor, Aileen. *The Ideas of the Woman Suffrage Movement, 1890-1920.* New York: W. W. Norton, 1981.

Lerner, Gerda. *Why History Matters.* New York: Oxford University Press, 1997.

————, ed. *Black Women in White America: A Documentary History.* New York: Vintage, 1972.

Lunardini, Christine. *What Every American Should Know About Women's History.* Holbrook, Mass.: Adams Media, 1997.

Matthews, Glenna. *Just a Housewife: The Rise and Fall of Domesticity in America.* New York: Oxford University Press, 1987.

Mills, Kay. *From Pocahontas to Power Suits: Everything You Need to Know About Women's History in America.* New York: Plume, 1995.

————. *A Place in the News: From the Women's Pages to the Front Page.* New York: Columbia University Press, 1990.

Morgan, Robin, ed. *Sisterhood Is Powerful: An Anthology of Writings from the Women's Movement.* New York: Random House, 1970.

Norton, Mary Beth. *Liberty's Daughters: The Revolutionary Experience of American Women, 1750-1800.* Boston: Little Brown, 1980.

Partnow, Elaine. *The New Quotable Woman: The Definitive Treasury of Notable Words by Women from Eve to the Present.* New York: Meredian, 1992.

Rogers, Katharine M., ed. *The Meredian Anthology of Early American Women Writers: From Anne Bradstreet to Louisa May Alcott, 1650-1865.* New York: Meredian, 1991.

Rose, Phyllis, ed. *The Norton Book of Women's Lives.* New York: W. W. Norton, 1993.

Ruiz, Vicki L., and Ellen Carol Dubois, eds. *Unequal Sisters: A Multicultural Reader in U.S. Women's History.* 2nd ed. New York: Routledge, 1994.

Sherr, Lynn, and Jurate Kazickas. *Susan B. Anthony Slept Here: A Guide to American Women's Landmarks.* New York: Times Books, 1994.

Smith, Jessie Carney, ed. *Epic Lives: One Hundred Black Women Who Made a Difference.* Detroit, Mich.: Visible Ink Press, 1993.

Solomon, Barbara Miller. *In the Company of Educated Women: A History of Women and Higher Education in America.* New Haven: Yale University Press, 1985.

Solomon, Martha M., ed. *A Voice of Their Own: The Woman Suffrage Press*. Tuscaloosa: University of Alabama Press, 1991.

Stevens, Doris. *Jailed for Freedom: American Women Win the Vote*. Rev. ed., edited by Carol O'Hare. Troutdale, Ore.: NewSage Press, 1995.

Ware, Susan. *Beyond Suffrage: Women in the New Deal*. Cambridge: Harvard University Press, 1981.

Wheeler, Marjorie Spruill, ed. *One Woman, One Vote: Rediscovering the Woman Suffrage Movement*. Troutdale, Ore.: NewSage Press, 1995.

Wood, Mary Louise, and Martha McWilliams. *The National Museum of Women in the Arts*. New York: Abrams, 1987.

General Works: Washington, D.C.

Bergheim, Laura. *The Look-It-Up Guide to Washington Libraries & Archives*. Osprey, Fla.: Beacham Publishing, 1995.

——————. *The Washington Historical Atlas*. Rockville, Md.: Woodbine House, 1992.

Duncan, Jacci. *Washington for Women: A Guide to Working and Living in the Washington Metropolitan Area*. Lanham, Md.: Madison Books, 1997.

Evelyn, Douglas E., and Paul Dickson. *On This Spot: Pinpointing the Past in Washington, D.C.* Washington, D.C.: Farragut Publishing Co., 1992.

Official Guide to the National Museum of American History. Washington, D.C.: Smithsonian Institution Press, 1990.

Ross, Betty. *A Museum Guide to Washington, D.C.* Washington, D.C.: Americana Press, 1986.

The Smithsonian Guide to Historic America: Virginia and the Capital Region. New York: Stewart, Tabori & Chang, 1989.

Biographies of and Books by Women in This Guide*

Addams, Jane. *The Second Twenty Years at Hull House.* New York: Macmillan, 1930.

——————. *Twenty Years at Hull House.* New York: Macmillan, 1910.

Alcott, Louisa May. *Life, Letters, and Journals.* Avenel, N.J.: Gramercy Books, 1995.

Anderson, Marian. *My Lord, What a Morning: An Autobiography.* New York: Viking Press, 1956.

Another Kind of War Story: Army Nurses Look Back to Vietnam. Lebanon, Pa.: A. Thompson, 1993.

Anthony, Carl Sferrazza. *As We Remember Her: Jacqueline Kennedy Onassis, in the words of her family and friends.* New York: HarperCollins, 1997.

Anthony, Susan B., Matilda J. Gage, and Elizabeth Cady Stanton. *History of Woman Suffrage.* 3 vols. Rochester, N.Y., 1887.

Bacon, Margaret Hope. *Valiant Friend: The Life of Lucretia Mott.* New York: Walker, 1980.

Baker, Jean H. *Mary Todd Lincoln: A Biography.* New York: Norton, 1989.

Barry, Kathleen. *Susan B. Anthony: A Biography of a Singular Feminist.* New York: Ballantine, 1990.

Barton, Clara. *The Red Cross: A History.* Washington, D.C.: Red Cross, 1898.

Bearden, Jim. *Shadd: The Life and Times of Mary Shadd Cary.* Toronto: NC Press, 1977.

Black, Allida M. *Casting Her Own Shadow: Eleanor Roosevelt and the Shaping of Postwar Liberalism.* New York: Columbia University Press, 1996.

The Book of Abigail and John: Selected Letters of the Adams Family, 1762-1783. Cambridge: Harvard University Press, 1976.

Bordin, Ruth. *Frances Willard: A Biography*. Chapel Hill: University of North Carolina Press, 1986.

Bourke-White, Margaret. *The Photographs of Margaret Bourke-White*. Boston: New York Graphic Society, 1975.

——————. *Portrait of Myself*. New York: Simon and Schuster, 1963.

Brooks, Paul. *This House of Life: Rachel Carson at Work*. Boston: Houghton Mifflin, 1972.

Brownmiller, Susan. *Shirley Chisholm: A Biography*. Garden City, N.Y.: Doubleday, 1971.

Breckinridge, Mary. *Wide Neighborhoods: A Story of the Frontier Nursing Service*. Lexington, Ky.: University Press of Kentucky, 1981.

Bundles, A'Lelia Perry. *Madam C. J. Walker*. New York: Chelsea House, 1991.

Burton, Shirley J. *Adelaide Johnson: To Make Immortal Their Adventurous Will*. Macomb, Ill.: Western Illinois University Press, 1986.

Butler, Susan. *East to the Dawn: The Life of Amelia Earhart*. Reading, Mass.: Addison-Wesley, 1997.

Carson, Rachel. *The Letters of Rachel Carson and Dorothy Freeman, 1952-1964*. Boston: Beacon Press, 1994.

——————. *Silent Spring*. Boston: Houghton Mifflin, 1951.

Cassini, Oleg. *A Thousand Days of Magic: Dressing Jacqueline Kennedy for the White House*. New York: Rizzoli International, 1995.

Catt, Carrie Chapman, and Nettie Rogers Shuler. *Woman Suffrage and Politics*. New York: Scribners, 1923.

Chesler, Ellen. *Woman of Valor: Margaret Sanger and the Birth Control Movement in America*. New York: Anchor, 1993.

Chicago, Judy. *The Dinner Party: A Symbol of Our Heritage*. Garden City, N.Y.: Anchor Books, 1979.

Clifford, Deborah Pickman. *Mine Eyes Have Seen the Glory: A Biography of Julia Ward Howe*. Boston: Little, Brown, 1979.

Cochran, Jacqueline. *Jackie Cochran: An Autobiography*. New York: Bantam, 1987.

——————. *The Stars at Noon*. Boston: Little, Brown, 1954.

Cook, Blanche Wiesen. *Eleanor Roosevelt*. Vol. I, 1884-1933. New York: Penguin, 1992.

Cooper, Anna J. *The Voice of Anna Julia Cooper: Including A Voice from the South and Other Important Essays, Papers, and Letters*. Lanham, Md.: Rowman & Littlefield, forthcoming.

DeCosta-Willis, Miriam, ed. *The Memphis Diary of Ida B. Wells*. Boston: Beacon Press, 1995.

Dickenson, Donna. *Margaret Fuller: Writing a Woman's Life*. Basingstoke: Macmillan, 1993.

Dubois, Ellen Carol, ed. *The Elizabeth Cady Stanton-Susan B. Anthony Reader: Correspondence, Writings, Speeches*. Boston: Northeastern University Press, 1992.

Dunnahoo, Terry. *Before the Supreme Court: The Story of Belva Ann Lockwood*. Boston: Houghton Mifflin, 1974.

Duster, Alfreda M., ed. *Crusade for Justice: The Autobiography of Ida B. Wells*. Chicago: University of Chicago Press, 1970.

Easter, Opal V. *Nannie Helen Burroughs*. New York: Garland, 1995.

Farrell, John C. *Beloved Lady: A History of Jane Addams' Ideas on Reform and Peace*. Baltimore: The Johns Hopkins University Press, 1967.

Felsenthal, Carol. *Alice Roosevelt Longworth*. New York: Putnam, 1988.

Ferraro, Geraldine. *Ferraro: My Story*. New York: Bantam, 1985.

Foresta, Merry A. *A Life in Art: Alma Thomas, 1891-1978*. Washington: Smithsonian Institution Press, 1981.

Fowler, Robert B. *Carrie Catt, Feminist Politician*. Boston: Northeastern University Press, 1986.

Frank, Anne. *The Diary of a Young Girl*. The Definitive Edition. New York: Doubleday, 1995.

Friedman, B. H. *Gertrude Vanderbilt Whitney: A Biography.* Garden City, N.Y.: Doubleday, 1978.

Gibson, Althea. *I Always Wanted to be Somebody.* New York: Harper and Row, 1958.

Goldberg, Vicki. *Margaret Bourke-White: A Biography.* New York: Harper & Row, 1986.

Graham, Katharine. *Personal History.* New York: Alfred A. Knopf, 1997.

Griffith, Elisabeth. *In Her Own Right: The Life of Elizabeth Cady Stanton.* New York: Oxford University Press, 1985.

Hale, Nancy. *Mary Cassatt.* Reading, Mass.: Addison-Wesley, 1987.

Hedric, Joan D. *Harriet Beecher Stowe: A Life.* New York: Oxford University Press, 1994.

Hellman, Lillian. *Pentimento.* Boston: Little, Brown, 1973.

——————. *Scoundrel Time.* Boston: Little, Brown, 1976.

——————. *An Unfinished Woman: A Memoir.* Boston: Little, Brown, 1969.

Hurston, Zora Neale. *Dust Tracks on a Road.* Philadelphia: J. B. Lippincott, 1942.

Hurwitz, Jane. *Sally Ride: Shooting for the Stars.* New York: Fawcett Columbine, 1989.

Hutchinson, Louise Daniel. *Anna J. Cooper: A Voice from the South.* Washington, D.C.: Anacostia Museum and Smithsonian Institution Press, 1981.

James, Bessie Rowland. *Anne Royall's U.S.A.* New Brunswick, N.J.: Rutgers University Press, 1972.

Johnson, Carmen. *Wave-Rings in the Water: My Years with the Women of Postwar Japan.* Alexandria, Va.: Charles River Press, 1996.

Johnston, Frances. *A Talent for Detail: The Photographs of Miss Frances Benjamin Johnston, 1889-1910.* New York: Harmony Books, 1974.

Jones, Beverly. *Quest for Equality: The Life and Writings of Mary Eliza Church Terrell.* Brooklyn, N.Y.: Carlson, 1990.

Josephson, Hannah. *Jeannette Rankin: First Lady in Congress.* Indianapolis: Bobbs-Merrill, 1974.

Kahlo, Frida. *The Diary of Frida Kahlo: An Intimate Self-Portrait.* London: Bloomsbury, 1995.

Keckley, Elizabeth. *Behind the Scenes, or, Thirty Years a Slave and Four Years in the White House.* Salem, N.H.: Ayer, 1993.

Keller, Helen. *The Story of My Life.* New York: Viking Penguin, 1903.

Kemble, Frances Anne. *Journal of a Residence on a Georgia Plantation in 1838-1839.* Ed. by John A. Scott. New York: Knopf, 1961.

Kennedy, David. *Birth Control in America: The Career of Margaret Sanger.* New Haven, Conn.: Yale University Press, 1970.

Kerr, Andrea Moore. *Lucy Stone: Speaking Out for Equality.* New Brunswick, N.J.: Rutgers University Press, 1992.

Kling, Jean L. *Alice Pike Barney: Her Life and Art.* Washington, D.C.: Smithsonian Institution Press, 1994.

Kollwitz, Käthe. *The Diary and Letters of Kaethe Kollwitz.* Evanston, Ill.: Northwestern University Press, 1988.

Kornfeld, Eve. *Margaret Fuller: A Brief Biography with Documents.* Boston: Bedford Books, 1997.

Lash, Joseph P. *Helen and Teacher: The Story of Helen Keller and Anne Sullivan Macy.* New York: Addison-Wesley, 1997.

Lear, Linda J. *Rachel Carson: Witness for Nature.* New York: Henry Holt, 1997.

Levin, Phyllis Lee. *Abigail Adams: A Biography.* New York: Ballantine, 1988.

Lewis, Samella. *The Art of Elizabeth Catlett.* Claremont, Calif.: Hancraft Studios, 1984.

Lisle, Laurie. *Portrait of an Artist: A Biography of Georgia O'Keeffe.* New York: Washington Square Press, 1997.

—————. *Louise Nevelson: A Passionate Life.* New York: Washington Square Press, 1991.

Longworth, Alice Roosevelt. *Crowded Hours: Reminiscences of Alice Roosevelt Longworth.* New York: Scribner's, 1933.

Lunardini, Christine A. *From Equal Suffrage to Equal Rights: Alice Paul and the National Woman's Party, 1910-1928.* New York: New York University Press, 1986.

MacCaffrey, Wallace T. *Elizabeth I.* New York: Edward Arnold, 1993.

The Madam C. J. Walker Beauty Manual: A Thorough Treatise Covering All Branches of Beauty Culture. Indianapolis, Ind.: The Madam C. J. Walker Manufacturing Co., 1928[?].

Martha Washington's Booke of Cookery and Booke of Sweetmeats. New York: Columbia University Press, 1995.

Martindale, Meredith. *Lilla Cabot Perry: An American Impressionist.* Washington, D.C.: National Museum of Women in the Arts, 1990.

Mead, Margaret. *Blackberry Winter.* New York: Morrow, 1972.

Mills, Kay. *This Little Light of Mine: The Life of Fannie Lou Hamer.* New York: Plume, 1993.

Mohr, Lillian Holman. *Frances Perkins: That Woman in FDR's Cabinet.* Croton-on-Hudson, N.Y.: North River Press, 1979.

Moore, Virginia. *The Madisons: A Biography.* New York: McGraw-Hill, 1979.

Nurses in Vietnam: The Forgotten Veterans. Austin, Tex.: Texas Monthly Press, 1987.

Oates, Stephen B. *A Woman of Valor: Clara Barton and the Civil War.* New York: Free Press, 1995.

Painter, Nell Irvin. *Sojourner Truth: A Life, A Symbol.* New York: W. W. Norton, 1996.

Parks, Rosa. *Rosa Parks: My Story.* New York: Dial Books, 1992.

Prelinger, Elizabeth. *Käthe Kollwitz.* New Haven: Yale University Press, 1992.

Rankin, Jeannette. *Jeannette Rankin: Activist for World Peace, Women's Rights, and Democratic Government.* Berkeley: Bancroft Library, University of California, 1974.

Rittenhouse, Mignon. *The Amazing Nelly Bly.* New York: E. P. Dutton, 1956.

Ross, Ishbel. *Power with Grace: The Life Story of Mrs. Woodrow Wilson.* New York: Putnam, 1975.

Rubin, Nancy. *American Empress: The Life and Times of Marjorie Merriweather Post.* New York: Villard Books, 1995.

Sanger, Margaret. *Margaret Sanger: An Autobiography.* New York: W. W. Norton, 1938.

————. *My Fight for Birth Control.* 1931. Elmsford, N.Y.: Maxwell Reprint Co., 1969.

Schmidt, Patricia L. *Margaret Chase Smith: Beyond Convention.* Orono: University of Maine Press, 1996.

Sherr, Lynn. *Failure Is Impossible: Susan B. Anthony in Her Own Words.* New York: Times Books, 1996.

Snyder, Charles McCool. *Dr. Mary Walker.* New York: Vantage Press, 1962.

Stein, Gertrude. *The Autobiography of Alice B. Toklas.* New York: Random House, 1933.

Sterling, Dorothy. *Lucretia Mott: Gentle Warrior.* Garden City, N.Y.: Doubleday, 1964.

Stern, Madeleine B. *Louisa May Alcott.* New York: Random House, 1996.

Stone, Lucy. *Friends and Sisters: Letters Between Lucy Stone and Antoinette Brown Blackwell, 1846-93.* Urbana: University of Illinois Press, 1987.

Tibor, Raquel. *Frida Kahlo: An Open Life.* Albuquerque: University of New Mexico Press, 1993.

Terrell, Mary Church. *Colored Woman in a White World.* Washington, D.C.: Ransdell Publishing, 1940.

Trindall, Elizabeth Steger. *Mary Surratt: An American Tragedy.* Gretna, La.: Pelican Publishing Co., 1996.

Truitt, Anne. *Daybook.* New York: Pantheon, 1982.

Van Voris, Jacqueline. *Carrie Chapman Catt: A Public Life.* New York: Feminist Press at the City University of New York, 1996.

Wald, Lillian. *The House on Henry Street.* New York: Holt, 1915.

Ware, Susan. *Still Missing: Amelia Earhart and the Search for Modern Feminism.* New York: Norton, 1993.

Wells-Barnett, Ida. *Southern Horrors.* Ida Wells-Barnett, 1892.

Willard, Frances E., and Mary A. Livermore. *A Woman of the Century.* Buffalo, N.Y.: Charles Wells Moulton, 1893.

Withey, Lynne. *Dearest Friend: A Life of Abigail Adams.* New York: Free Press, 1982.

Woodward, Grace Steele. *Pocahontas.* Norman: University of Oklahoma Press, 1969.

* Sadly, many autobiographies, especially, on this list are out of print. However, they are often available in libraries, and some excerpts appear in anthologies, such as the Conway, Guy-Sheftall, and Rose collections in the list of general works.

ADDITIONAL RESOURCES
FOR RESEARCH

In addition to information provided in the site entries, the following resources are recommended for women's history research. For details on these and other resources, see Laura Bergheim's *Look-It-Up Guide to Washington Libraries and Archives.*

African-American Women's Institute (AAWI)
AAWI's holdings chronicle black women's history, especially in the upper southern United States. The institute examines regions based on the contributions of women to culture and the economy, as well as the complexities of race, gender, and class.
Howard University, Department of Sociology/Anthropology
P.O. Box 987, Washington, DC 20059
202/806-6853

Anacostia Museum Resource Center and Archives
The center contains a wide variety of materials and artifacts on the history of African-Americans. Researchers may use the center by appointment only.
Anacostia Museum, 1901 Fort Place, SE, Washington, DC
202/357-4500

Center for African American History and Culture
This center, which is part of the Smithsonian Institution, includes photographs, publications, and other materials on African American history and culture. Hours: Mon.-Fri., 10 am-5:30 pm
Anacostia Museum, 1901 Fort Place, SE, Washington, DC
202/357-4500

DAR Library

The DAR Library includes more than 105,000 genealogy publications, including unpublished works unavailable elsewhere, and books on U.S. state and local history. The collection includes nearly 13,000 volumes of genealogical records, 35,000 documented family histories, genealogical manuscripts, such as notes and personal letters, a special collection documenting Native American history, historical sources of the American Revolution, city directories, and genealogical periodicals. Open Mon.-Fri., 9 am-4 pm; Sun., 1-5 pm. Closed holidays and during April.
1776 D St., NW, Washington, DC
202/879-3229

Historical Society of Washington, D.C., Research Library

This library contains materials that document Washington's people, neighborhoods, institutions, and architecture. The collection includes books, files, microforms, articles, manuscripts, newspaper clippings, photographs, prints, and maps documenting the city's history. The library also provides a fee-based research services for researchers who are unable to visit. Ask for the reference librarian at the listed phone number. Nonmembers are charged $3 per visit to use the research facility.
1307 New Hampshire Ave., NW, Washington, DC 20036
202/785-2068

Moorland-Spingarn Research Center

This research center at Howard University holds one of the most comprehensive collections of materials documenting African-American history and culture. Mon.-Thurs., 9 am-4:45 pm, Fri. 9 am-4:30 pm., Saturday 9 am-5 pm.
Howard University
500 Howard Place, NW, Washington, DC
202/806-6100

National Archives Library

Located at the National Archives and Records Administration, the National Archives Library contains a small yet informative collection on women's history. In addition to bibliographies, reference works, journals, documents, monographs, anthologies, and other materials, the archives contain reference materials on women as they pertain to the following areas: African-American culture, family and children, the American Revolution, suffrage, temperance, labor, reform, society, war, and the West. To access a full summary of archive offerings via the Internet, visit the home page: http://www.nara.gov and select women's history. Several guides to women's history materials in the collection are available on this home page. Hours: 9 am-3:30 pm.

Room 201, Washington, DC 20408

Reference: 202/501-5421

National Archives at College Park

8601 Adelphi Road, College Park, MD 20740-6001

Librarians at Archives II: 301/713-6875

National Archives for Black Women's History

The National Archives for Black Women's History, located at the Mary McLeod Bethune Council House, serves as a research and archive repository for African-American women's history. The center contains the National Archives for Black Women's History, including the personal papers of history-making African American women, records of their organizations, and more than 3,500 photographs that document the achievements of African-American women. Archives are open on weekdays by appointment.

1318 Vermont Ave., NW, Washington, DC 20005

202/332-1233

Society of Woman Geographers

This society was founded in 1925 by a small group of women to provide a medium of exchange among traveled women engaged in geographical work and its allied fields—ethnology, archaeology, anthropology, biology, natural history, folklore, etc. At the headquarters, a small museum offers photographic displays of the work of society members around the world. The library contains more than 1,000 books by members ranging from Amelia Earhart and Margaret Mead to Jane Goodall, Sylvia Earle, and Pam Flowers. The museum and library are available by appointment only to those engaged in serious research on women in the field of geography and its related disciplines.
415 E. Capitol St., SE, Washington, DC
202/546-9228

Star Spangled Banner Flag House

The Star Spangled Banner Flag House is the former house and current museum of Mary Pickersgill, who created the original Star Spangled Banner flag in 1812 that flew over Fort McHenry and ultimately was the inspiration for America's national anthem. The house contains objects connected with Pickersgill and the War of 1812, including fragments of the flag, the original billing receipt for it, her desk, and her French clock. Hours: Tues.-Sat. 10 am-4 pm
844 E. Pratt St., Baltimore, MD 21202
410/837-1812

Warren M. Robbins Library

This library, located at the National Museum of African Art, contains publications and materials on African art, artists, culture, and history. Hours: Mon.-Fri., 9 am-5:15 pm
National Museum of African Art
950 Independence Ave., SW, Washington, DC
202/357-4600, ext. 286

NMWA Library and Research Center

The Library and Research Center at the National Museum of Women in the Arts contains publications and other materials on more than 10,000 female artists. The collection includes rare publications, monographs, exhibition catalogues, artists' books, periodicals, and special collections of female artists. Hours: Mon.-Sat., 10 am-5 pm; on Sundays by appointment
1250 New York Ave., NW, Washington, DC
202/783-5000

Textile Museum and Learning Center/Arthur D. Jenkins Library

This museum collection and learning center contain more than 15,000 rugs and textiles, with a portion of these on exhibit at any one time. The Learning Center is comprised of the Activity Gallery and the Collections Gallery, which includes interactive exhibits where visitors can learn about spinning, dyeing, weaving, and other ways to produce handmade textiles. The library contains books, publications and visual resources on textile history and processes. Hours: Mon.-Sat., 10 am-5 pm, and Sun. 1-5 pm, closed major holidays. The library is open by appointment only during museum hours.
2320 S St., NW, Washington, DC
202/667-0441

PHOTO CREDITS

p. 12 (Anthony): LC USZ62-7140, Prints and Photographs Division, Library of Congress. Photo by Catherine Wetherfield. (Frances Johnston took this photograph of Anthony, c. 1900.)

p. 14 (Minerva): Office of Public Affairs, Library of Congress.

p. 17 (Paul): LC LC USZ62-37937, Prints and Photographs Division, Library of Congress. Photo by Catherine Wetherfield.

p. 18 (Sewall-Belmont House): LC USZ62-78693, Prints and Photographs Division, Library of Congress. Photo by Catherine Wetherfield.

p. 22 (suffrage monument): Architect of the U.S. Capitol.

p. 23 (Ream): LC USZ62-10284, Prints and Photographs Division, Library of Congress. Photo by Catherine Wetherfield.

p. 30 (O'Connor): Courtesy of U.S. Supreme Court.

p. 30 (Ginsburg): Courtesy of U.S. Supreme Court.

p. 37 (Anderson): LC USZ62-21526, Prints and Photographs Division, Library of Congress. Photo by Catherine Wetherfield.

p. 45 (astronauts): National Aeronautics and Space Administration, #S-78-34665.

p. 51 (Iriabo): Iriabo (Clapping Girl), 1987. Artist: Sokari Douglas Camp (b. 1958), Nigerian. Copper, steel, wood, paint, electric motor. 140 cm (55 in). Lent by Contemporary African Art Gallery, New York. National Museum of African Art. Photograph by Jeffrey Ploskonka.

p. 55 (first ladies' gowns): Courtesy of National Museum of
American History, Smithsonian Institution.

p. 57 (kitchen): Courtesy of National Museum of American History,
Smithsonian Institution.

p. 58 (suffragists): Courtesy of the Sewall-Belmont House.

p. 68 (Senesh): Beit Hannah Senesh, courtesy of USHMM Photo
Archives (neg. 1891-3786)

p. 72 (Vietnam memorial): Copyright Annie E. Scarborough, 1997.

p. 78 (Adams memorial): Copyright Annie E. Scarborough, 1997.

p. 83 (Terrell): Courtesy of the Anacostia Museum, Smithsonian
Institution.

p. 86 (Bethune & Roosevelt): Courtesy of the Mary McLeod Bethune
Council House, National Park Service.

p. 93 (Lewis sculpture): Edmonia Lewis, *The Death of Cleopatra,*
c. 1875. Gift of the Historical Society of Forest Park, IL.
National Museum of American Art, Smithsonian
Institution.

p. 94 (Spencer painting): Lilly Martin Spencer (1822-1902), *We Both
Must Fade (Mrs. Fithian),* 1869. Museum purchase.
National Museum of American Art, Smithsonian
Institution.

p. 95 (Brooks painting): Romaine Brooks (1874-1970), *Self-Portrait,*
1923. Gift of the artist. National Museum of American Art,
Smithsonian Institution.

p. 99 (Claudel bronze): Camille Claudel, French (1864-1943), *Young
Girl with a Sheaf,* c. 1890. Bronze. 14 1/8 x 7 x 7 1/2 in.
The National Museum of Women in the Arts/The Holladay
Collection.

p. 100 (Kahlo painting): Frida Kahlo (1907-1954), *Self-Portrait
Dedicated to Leon Trotsky,* 1937. Oil on masonite, 30 x 24
in. (76.2 x 61 cm.) The National Museum of Women in
the Arts.

p. 102 (NMWA): The Great Hall of the National Museum of Women in the Arts. Photography by Robert Isacson. Courtesy NMWA Public Affairs Office.

p. 106 (Parks): National Portrait Gallery, Smithsonian Institution.

p. 111 (Madison): LC USZ62-68175, Prints and Photographs Division, Library of Congress. Photo by Catherine Wetherfield.

p. 114 (Kennedy): LC USZ62-21796, Prints and Photographs Division, Library of Congress. Photo by Catherine Wetherfield.

p. 120 (Joan of Arc statue): Copyright Annie E. Scarborough, 1997.

p. 127 (Delano statue): Copyright Annie E. Scarborough, 1997.

p. 131 (Clara Barton): National Park Service, Clara Barton National Historic Site.

p. 133 (Mount Vernon): Mount Vernon Ladies Association.

p. 136 (Johnston): LC USZ62-64301, Prints and Photographs Division, Library of Congress. Photo by Catherine Wetherfield.

p. 137 (Wells): LC USZ62-107756, Prints and Photographs Division, Library of Congress. Photo by Catherine Wetherfield.

p. 139 (Watergate necklace): The Newseum.

p. 142 (Walker): LC USZ621-15558, Prints and Photographs Division, Library of Congress. Photo by Catherine Wetherfield.

INDEX

(page numbers in bold refer to illustrations)

ABOUT THE AUTHORS

JACCI DUNCAN is a journalist and consultant on women's issues in Washington, D.C. She has written on a range of topics, including gender issues, politics, health care, economics, and business issues. She worked as a television and print news reporter in the Sacramento area for six years. Her first book, *Washington for Women: A Guide to Working and Living in the Washington Metropolitan Area*, is a comprehensive guide to personal and professional resources for women. A native of California, she holds a degree in philosophy from the University of California at Los Angeles. She is a member of the board of the Women's National Book Association's Washington chapter and will always be an avid tourist in Washington.

LYNN PAGE WHITTAKER is publisher and editor-in-chief of Charles River Press, which she launched in fall 1995. A native of Georgia, she holds degrees from the University of Georgia and Georgia State University and did graduate work at Harvard and MIT. For eight years, she worked at Harvard's Kennedy School of Government as an editor, program manager, and executive director of a research center. Her first job after moving to Washington in 1989 was director of publications at the Close Up Foundation, an educational association. She currently divides her time among Charles River Press, freelance editing and writing, and teaching in the publications programs of Georgetown and George Washington universities. A past president of the Women's National Book Association's Washington chapter, she also represents selected writers as a literary agent with the firm of Graybill and English.